The Environment for Women's Entrepreneurship in the Middle East and North Africa

ORIENTATIONS IN DEVELOPMENT

The Environment for Women's Entrepreneurship in the Middle East and North Africa

Nadereh Chamlou

THE WORLD BANK

Washington, D.C.

ISBN-13: 978-0-8213-7495-5
e-ISBN: 978-0-8213-7496-2
DOI: 10.1596/978-0-8213-7495-5

Cover photo: istock.

Library of Congress Cataloging-in-Publication data has been applied for.

Contents

v

Preface

Why do we need to be concerned about entrepreneurship in the Middle East and North Africa? Why do we need to be concerned about women's entrepreneurship? And, why now? It is because, at this juncture in the economic development of the Middle East and North Africa, unlocking women's skills and creativity can make valuable contributions to testing new ideas and increasing competitiveness in the global marketplace, spotting new niches for diversifying the economy's range of products and services, and developing a cadre of women entrepreneurs who can lead in their communities and countries.

Although public policy sets broad directions and builds the momentum and consensus for change, it is the private sector and its entrepreneurs that translate these policies into sustainable action—for creating jobs and wealth, supporting technical progress, increasing exports, combating communicable diseases, cleaning up the air, or even overcoming discrimination. Few agendas move forward by fiat alone. Most require buy-in and action by the private sector.

The only way to increase efficiency and effectiveness is to allow more entrepreneurs to compete in the marketplace by testing new ideas and creating new comparative advantages in supply, cost, and quality. But, in many parts of the world, large well-established companies have advantages as political and financial insiders. And many young and new entrepreneurs, as outsiders, have difficulty getting off the ground. Entrepreneurship is still fairly male-dominated worldwide, leaving women even farther on the outside. By reducing the barriers women face, the business market can be more open, and competition can flourish. In short, what works for women is likely to work for everyone.

Businesses do not have enough skilled and creative employees. Although the public and policy makers are correct to sound the alarm over some educational failings, many overlook the waste of human capital in the higher education of graduates who cannot find work largely because they are female. Women in the Middle East and North Africa earn more

than half of all university degrees. Yet their unemployment and under-employment rates are high, so the region's economies suffer a "hidden domestic brain drain." Lowering the hurdles to entrepreneurship for women can free a large pool of talented women to carve out opportunities for themselves and create jobs for others.

Promoting women's entrepreneurship in the Middle East and North Africa is important now because the region's economies need to diversify and create more and better jobs. The recent economic boom offers an opportunity that should not be missed. Women entrepreneurs can spot new niches that create and cater to new consumer choices. And with the rise of electronic commerce, they can find it easier to grow these niches into bigger markets.

Women may even have an advantage in spotting such new niches. They control a large proportion of the family's purchasing and product selection. This puts them in tune with their communities, so that they can detect new needs. Indeed, across neighborhoods and countries, women own and operate small and home-based businesses. Some become formal firms, but others stay behind the barriers to their entrepreneurship. If those barriers were lowered, many of these niche businesses could develop into formal businesses, their products improved, their markets broadened.

Finally, entrepreneurs have leadership traits that can be applied to other spheres of public life. Resourceful and creative, they have the vision to become a success. They assess and take risks and they inspire others. They understand well the forces of economics and globalization. They persevere in face of adversity. They know how to negotiate and create opportunities. And they have access to networks of information and influence. Women entrepreneurs thus possess abilities that prepare them to become effective leaders in their communities and countries.

The challenge is that women still do not have equal access to economic opportunities. Despite their educational gains, they face more barriers inside and outside the labor market. And despite their capabilities and business potential, they face additional barriers in the business environment. The payoffs to lowering these barriers are a more diversified private sector, an effective use of the talent in the region, and the development of a cadre of entrepreneurs to lead in grasping opportunities for themselves and their communities and countries.

Mustapha K. Nabli
Chief Economist
Middle East and North Africa Region
The World Bank

Acknowledgments

This report was produced under the direction of Dr. Mustapha K. Nabli, Chief Economist of the Middle East and North Africa Region. The main author of the report is Nadereh Chamlou (Senior Advisor and Gender Coordinator). The core team consists of Leora Klapper (Senior Economist, responsible for chapter 4's attitudes section), Marjan Ehsassi (Consultant), Francesca Lamanna (Consultant), Talajeh Livani (Consultant), Silvia Muzi (Consultant), Seemeen Saadat (Consultant), Federica Saliola (Consultant), and Neda Semnani (Consultant). Peer reviewers are Mark Blackden (Lead Specialist) and Mark Sundberg (Lead Economist). Krisztina Mazo provided valuable support. The report was edited by Bruce Ross-Larson, Laura Peterson Nussbaum, and Zach Schauf of Communications Development Incorporated.

The team is grateful for the excellent verbal and written comments from Amanda Ellis, Andrew Stone, Carlos Silva-Jauregui, Carmen Niethammer, David Steer, Elena Bardasi, Farrukh Iqbal, Fatemeh Moghadam, Guity Nashat, Isabelle Bleas, Jack Roepers, Joseph Saba, Mary Hallward-Driemeier, Michaela Weber, Mona Khalaf, Najy Benhasine, Omer Karasapan, Rashida Hamdani, Sahar Nasr, Soukeina Bouraoui, Tatyana Leonova, Theodore Ahlers, Wendy Wakeman, Yasmina Reem Limam, and Zoubida Allaoua.

Abbreviations

EAP	East Asia and Pacific (World Bank region)
ECA	Europe and Central Asia (World Bank region)
GDP	gross domestic product
HDI	Human Development Index
KILM	Key Indicators of the Labor Market
LAC	Latin America and the Caribbean (World Bank region)
MENA	Middle East and North Africa (World Bank region)
OECD	Organisation for Economic Co-operation and Development
PCA	principal components analysis
SA	South Asia (World Bank region)
SSA	Sub-Saharan Africa (World Bank region)
WDI	World Development Indicator
WVS	World Values Survey

Overview

This report is about how women entrepreneurs can contribute more to the quality and direction of economic and social development in the Middle East and North Africa (MENA) region. Economic growth in the Middle East has been remarkable since 2004, mainly because of higher oil prices. Rapid job growth has followed, driven mainly by the private sector. Yet the region still faces two important challenges: the first is to create better jobs for an increasingly educated young workforce; the second is to diversify its economies away from the traditional sectors of agriculture, natural resources, construction, and public works and into sectors that can provide more and better jobs for young people—sectors that are more export oriented, labor intensive, and knowledge driven. These goals can be achieved only by more innovative and diverse investors. In this, the private sector must play an even bigger role than in the past.

The region also faces another important challenge—empowering women—particularly in the economic and political spheres, where their participation remains the lowest of any region. Some decades ago women were less educated and constituted a mere fraction of the region's human capital. Barriers that held them back levied a relatively smaller economic cost than today, now that women, after decades of investment in their education, account for nearly half the region's human capital, especially among the younger generations. The costs of gendered barriers are now larger.[1]

Promoting women's entrepreneurship can partly address these three challenges—and produce a cadre of women leaders. Indeed, policy makers, governments, and donors have paid much attention to promoting women entrepreneurs, particularly given that women have strong economic rights in Islam and that there is a tradition of women in business. Islam has a powerful role model in the first wife of the Prophet Mohammed, Khadija, a wealthy trader and powerful businesswoman of her time who was pivotal in the rise of Islam.

What the Report Does—and What It Does Not Do

The recent interest in women's entrepreneurship in the MENA region has spurred a number of studies that aim to identify the challenges facing women entrepreneurs. In all these studies, women entrepreneurs felt empowered. Because the data in most of these studies did not cover male entrepreneurs, however, it is not possible to say for certain whether women faced gender-based barriers or barriers common to everyone.

This report is different. Its objective is to provide a better understanding of barriers to investment and doing business that may be common to all investors and those that affect women entrepreneurs disproportionately. The report examines newly available data from more than 4,800 surveyed firms in the formal sector in eight Middle East and North African countries (the Arab Republic of Egypt, Jordan, Lebanon, Morocco, Saudi Arabia, the Syrian Arab Republic, Gaza and the West Bank, and the Republic of Yemen). These surveys detail firm characteristics and the responses of male- and female-owned firms to questions about perceived barriers along 18 categories of the investment climate. The purpose of the report is threefold:

- to provide an overview of the characteristics of female-owned firms in the region;

- to analyze gender-specific barriers that exist across the region or within countries; and

- to identify other factors outside the business environment that might affect women's entrepreneurship.

The report finishes with policy recommendations on how to reduce the identified barriers and create a level playing field for women entrepreneurs.

The report acknowledges limitations resulting from the availability and depth of data. It does not attempt to answer every question about women's entrepreneurship in MENA. Indeed, it may raise more questions than it answers. The hope is to spur greater interest in the topic among researchers and policy makers.

Female-Owned Firms Are Few—but They Defy Commonly Held Perceptions

Of the 4,832 firms surveyed by the World Bank, a woman is the principal owner of about 13 percent—a little over one in eight. Women entrepreneurs are a minority everywhere, but their share in MENA is far lower

than in the other middle-income regions of East Asia and Pacific (EAP), Latin America and the Caribbean (LAC), and Europe and Central Asia (ECA).

The widely held perception is that the few female entrepreneurs in the MENA region are mainly in the informal or formal micro sector (employing fewer than 10 workers), producing less sophisticated goods and services. This perception is wrong. Of the formal-sector female-owned firms surveyed, only 8 percent are micro firms (figure 1). More than 30 percent are large firms employing more than 100 workers.

Female-owned firms are as well-established as male-owned firms. About 40 percent of female-owned firms are individually owned—an impressive figure, even if less than the 60 percent of male-owned firms. And in Syria and Morocco, the two countries with relevant data, more than 65 percent of female-owned firms are managed by the owner, debunking the myth that women are owners in name only. In sectoral distribution, female-owned firms are much like male-owned firms, with nearly 85 percent in manufacturing and 15 percent in services, compared with 88 percent of male-owned firms in manufacturing and 12 percent in services.

Female-owned firms are also active exporters, and a high share attract foreign investors and are heavy users of information technology—all key ingredients for global competitiveness. Regionally, female-owned firms are as frequently exporters as male-owned firms, and they are substan-

FIGURE 1

Female-Owned Firms Are Often as Large as Male-Owned Firms

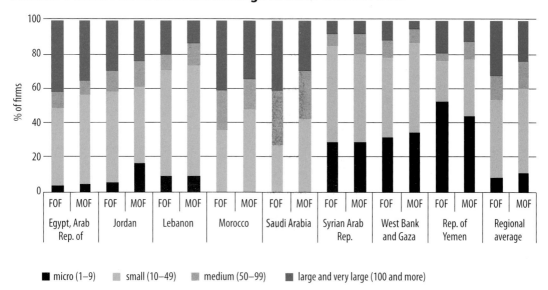

■ micro (1–9) ■ small (10–49) ■ medium (50–99) ■ large and very large (100 and more)

Source: Staff estimates based on World Bank Enterprise Survey data.

Note: FOF = female-owned firms; MOF = male-owned firms. Regional average is across firms.

tially more often so in Egypt, Jordan, and Morocco. In Morocco, foreign investors have a more significant presence in female-owned firms than in male-owned firms. Female-owned firms are also more likely to regularly use e-mail and Web sites in their interactions with clients.

Female-owned firms offer good jobs. Workers in female-owned firms are about as educated and as skilled as those in other firms. In Egypt, for instance, 19 percent of workers in female-owned firms have professional competencies, compared with just 16 percent in male-owned firms.

Female-owned firms hire more women. Women make up about 25 percent of the workforce in female-owned firms, compared with 22 percent in male-owned firms. This difference may not seem large, but female-owned firms also employ a higher share of female workers at professional and managerial levels. Male-owned firms employ more women in unskilled positions.

Female-owned firms are also hiring more workers in general. In Egypt, Jordan, Saudi Arabia, and the West Bank and Gaza, the share of female-owned firms that have increased their workforces recently exceeds the share of male-owned firms that have done so (figure 2).

The productivity of female-owned firms compares well with that of male-owned firms. There are only small differences between male- and female-owned firms in labor productivity (measured by value added per permanent worker) and in sales.

Women's Entrepreneurship Is Not Reaching Its Potential

Given the promise and success of female-owned firms, why are there not more? Do female-owned firms face different and additional hurdles compared with male-owned firms?

Gendered differences across some countries and for some aspects of the business environment within countries suggest a degree of differential treatment of firms based on the gender of the principle owner. However, the finding of this report is that the business environment in the MENA region is not itself systematically gendered for the firms in the sample.

More striking is that all firms in MENA perceive the business environment as more cumbersome than do firms in other middle-income regions, regardless of the owner's gender (in general and acknowledging issues of aggregation; figure 3).

Country-level analysis confirms the perceptions of high barriers among both male- and female-owned firms in MENA. No clear gendered pattern emerges in any of the categories—for no constraint do female-owned firms systematically report a worse perception across all

FIGURE 2

Female-Owned Firms Are Hiring More Workers in Egypt, Jordan, Saudi Arabia, and the West Bank and Gaza

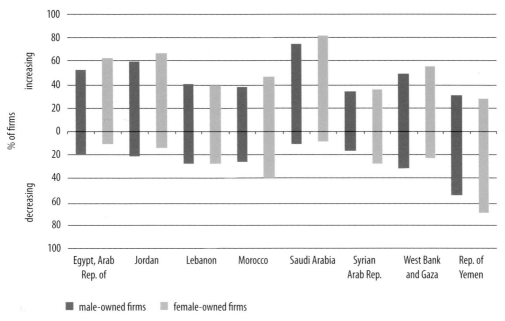

Source: Staff estimates based on World Bank Enterprise Survey data.

Note: Data refer to the percentage of enterprises increasing or decreasing their workforces between 2001 and 2000. Data for the West Bank and Gaza refer to 2001 and 1999. The upper point of each bar reports the percentage of firms that increased their workforces, and the percentage of firms decreasing their workforces is reported by the lower point.

countries in the region. Nor are there any countries where female-owned firms report all the constraints as more binding than do male-owned firms. Differences in firm perceptions do appear, however, in some countries and for some categories within countries.

A more clearly gendered pattern emerges in the Republic of Yemen and Lebanon, which have the most statistically significant gendered constraints. This is surprising: Yemen and Lebanon are on opposite ends of the spectrum in their social configurations, confessional diversity, degrees of economic and social openness, and (above all) per capita incomes.

In other countries, differences between male- and female-owned firms exist but are less systematic. Moroccan female-owned firms disproportionately perceive the availability of skilled and educated workers as a major constraint; in Jordan female-owned firms are more likely to perceive labor regulation and policy uncertainty as binding constraints. In the West Bank and Gaza, female-owned firms are more likely to perceive as binding telecommunications and access to land and to workers (in terms of both labor regulation and the availability of skilled and educated workers).

FIGURE 3

A Binding Investment Climate for All Firms in the Middle East and North Africa

(barriers reported by firms as major or very severe constraints)

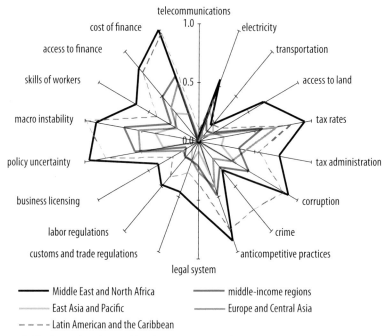

Source: Staff estimates based on World Bank Enterprise Survey data.

Note: Indexes are based on World Bank Enterprise Survey data. Values are normalized by maximums and minimums for each indicator. The index ranges from 0 (best perception) to 1 (worst perception).

In Egypt, female-owned firms are more likely than male-owned firms to perceive access to land and electricity as constraints—factors that are statistically significant. Female-owned firms in Egypt report a yearly average of 40 percent more power interruptions and losses of sales resulting from power outages or surges from the public grid. They also report higher legal constraints than do male-owned firms—an average of eight months longer to resolve disputes over overdue payments.

By contrast, the responses of male- and female-owned firms in Syria are similar to each other, indicating that none of the constraints are significantly gender biased. Perhaps a surprise, the business environment does not appear to be gendered in Saudi Arabia either. This could indicate that the business environment in Saudi Arabia is indeed gender neutral—or that there are no differences between male- and female-owned firms because both are managed by men with mainly male employees, given that the share of female employees in Saudi firms is low.

Female-owned firms do, however, still report transportation as a statistically significant barrier. Male-owned firms do not.

Not all the differences go against female-owned firms. The responses of female-owned firms are more positive for labor regulations in Egypt and Saudi Arabia. This could suggest that female-owned firms are more willing than male-owned firms to work within the tight labor regulations of the region. It may also explain why female-owned firms hire more women—normally perceived as more costly and constraining because of gender-specific protective benefits and regulations. Transportation is also less often reported as a binding problem in Lebanon and the Republic of Yemen, an interesting finding given that in Yemen female-owned firms are more often located outside the capital.

Even more surprising is that access to finance, long touted as a gendered barrier, is not significant in any of the countries except the Republic of Yemen. This finding does not mean that finance is not a considerable barrier to businesses. It just means that male- and female-owned firms face the same high barriers.

Is It More Difficult to Start Female-Owned Firms?

The business environment in the MENA region may not be as gendered as presumed for this sample of formal firms, with the exception of selected barriers in some countries. These barriers could still impact the performance of female-owned firms. However, women also face gender-based barriers outside the business environment that discourage them from starting a business. The report identifies three factors that may explain why there are fewer women entrepreneurs in this region than in others.

First, attitudes toward women and work may be less favorable to working women and, by extension, to female entrepreneurship. In some parts of the region there is still stigma attached to women's employment (as a poor reflection on her male kin's ability to provide) or belief that men are more deserving of scarce jobs, especially given the region's past high unemployment. The analysis in this report shows that attitudes toward working women—and women's work more generally—are less favorable in MENA than in other regions. Across regions, attitudes toward women's employment and women's work outside the home are correlated with entrepreneurship outcomes.

Second, gender-neutral barriers could have gender-differentiated effects. Cumbersome and costly procedures for opening a business and uncertain chances of recovering assets from a failed venture may be more difficult for women to overcome. Numerous and complicated procedures

provide more opportunities for rent-seeking and corruption, which both male- and female-owned firms rate as more problematic in MENA than in other regions. Corruption is negatively correlated with women's entrepreneurship, and empirical evidence demonstrates that women are averse to risk and loss and that cumbersome procedures increase their perceptions of risk. According to the World Bank's Doing Business 2008, countries with more cumbersome business environments have smaller shares of women entrepreneurs and vice versa (figure 4); simplifying business processes is likely to create more first-time female business owners at a rate 33 percent faster than for their male counterparts.

Third, a survey of business lawyers conducted for this report indicates that the region's business and investment laws are largely gender neutral or gender blind. Laws in other areas, however, are gendered and can influence the implementation and interpretation of business laws, further reinforced by gender-based perceptions and attitudes. This happens despite unequivocal constitutional statements that women are equal citizens and despite their strong economic rights under the shari`a (the basis for Islamic law that forms part of the legal framework).

According to this report's survey of lawyers, family laws and regulations can influence economic legislation because women are sometimes considered "legal minors." Women entrepreneurs, for example, consistently cite as a hurdle the requirement to obtain a male relative's permission to travel, which can result in additional bureaucratic steps. And the implementation of business and economic laws can be influenced by interpretations of gender roles, especially by conservative judiciaries.

FIGURE 4

A Lower Share of Women Entrepreneurs Where Doing Business Is More Difficult

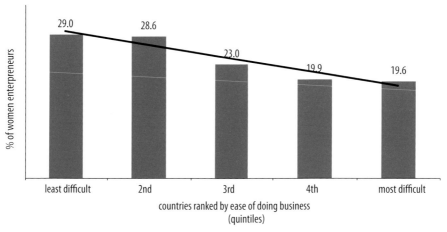

Source: World Bank Doing Business 2008.

Note: Relationships are significant at the 1 percent level and remain significant controlling for income per capita.

Judges may rule in favor of male plaintiffs even in such cases as settling firm receivables, on the basis that men are responsible for the family.

The combination of these forces can create ambiguities, leading to gendered interpretation and implementation of gender-neutral economic laws.

How to Promote Women's Entrepreneurship

Consider female labor force participation in MENA. The parallels with women's entrepreneurship are striking. Female labor force participation is low despite significant gains in education. Women still do not join the labor market because of a variety of social norms. Those who do join find few opportunities, evidenced by discouragingly high female unemployment rates—suggesting that women still face barriers inside and outside the labor market. Those who overcome the barriers, however, are able to do well.

The same pattern holds for women's entrepreneurship: the characteristics and performance of female-owned firms do not explain why there are not more. And those that overcome barriers do well.

Women entrepreneurs can play a greater role than in the past—creating more and better jobs, diversifying economies into modern sectors, and empowering women. By contributing new ideas, technologies, and production methods, these businesses can boost productivity growth across the economy, even spurring existing firms to raise their productivity. This report proposes two policy pillars to support women entrepreneurs:

- *Reform the business environment to help create opportunities for all investors, especially women, while addressing the few existing gender-specific hurdles.* Most Middle Eastern and North African economies are still dominated by the state sector. Although the last few years have seen rapid growth and job creation in the private sector, the private sector remains hindered by high barriers to firm entry, operation, and exit. Economies in the region need to draw in all potential entrepreneurs, producers, and investors. Women with education, ideas, aptitude, and financial resources want to participate.

 Addressing areas that demonstrate a degree of gender bias is a good start. Governments might also consider such proactive policies as including more women in unions and associations. Doing so is also necessary so that these organizations reflect the perspective and gain the support of women entrepreneurs. And women's advocacy groups, rather than focusing on narrow gender issues, might join forces (and

voices) with those pushing for overall reform of the business environment.

- *Mitigate social norms and gender-differentiated legal treatment that affect women in particular.* As more and more families depend on two paychecks to make ends meet, women's work outside the home is increasingly a necessity for families in MENA. Attitudes toward women's work need to change from considering it unnecessary and detrimental to family welfare to seeing it as a valuable contribution to society. Promoting the environment and the infrastructure to better balance work and family is crucial.

 Economic and business legislation are gender blind. So, though a woman has full rights to manage her finances and business independently, as stipulated by the shari`a, in other areas of the law she is considered a "legal minor," and her interactions with the state must be mediated through her male kin. The result is that additional uncertainties are faced by female entrepreneurs but not by their male counterparts. Such requirements also lead to legal inconsistencies and opaqueness, whether stemming from state regulations to protect the family or measures to uphold family law. Legal opaqueness translates into gendered legal interpretations and differential treatment.

Note

1. "Gendered" in this report means phenomena that are gender differentiated between men and women.

The Middle East's Economic Challenges

Women's entrepreneurship is less common in the Middle East and North Africa (MENA) than in other developing regions—but different from what stereotypes about the region might suggest. True, women own fewer firms in the Middle East than in other middle-income countries, but these firms tend to be as large, productive, and well-established as their male-owned counterparts. In some countries, such firms are more open to foreign investment and participation in export markets. The potential for female-owned firms to become an engine of growth and a tool for women's empowerment is great—but only if policy makers tackle the barriers that slow entrepreneurs' creation of new firms and that affect firms currently operating, potentially preventing them from growing and achieving their potential. Such barriers hurt businesses throughout the region, but in some cases they affect women more, making it difficult for them to start businesses and to perform to their potential.

This report offers guidance for policy makers and stakeholders contemplating reforms to the investment climate. Its main finding: all entrepreneurs in the region face highly binding barriers in the investment climate, with few differences between male and female entrepreneurs. Even so, some elements of the investment climate are gender-differentiated. And women seem to face hurdles outside the investment climate—hurdles that hold them back from participating in the formal economy.

Studies of gender and economic development in the Middle East have focused on women mostly as economic agents in labor markets. But women are also producers, entrepreneurs, and direct or portfolio investors. This report sheds new light on women's entrepreneurship and female-owned firms in the Middle East.

The report presents newly available data on this topic, important given the paucity of statistics and research. It acknowledges the limitations posed by the availability and depth of data. It does not attempt to answer every question about women's entrepreneurship in MENA. Indeed, it may raise more questions than it answers.

Recent Developments

Economic growth in the Middle East has been remarkable since 2004, mainly because of higher oil prices. Rapid job growth has followed. Between 2000 and 2005, annual employment growth reached 4.5 percent a year, adding 3 million jobs a year and outstripping annual labor force growth of 2.8 million. Unemployment fell from 14.3 percent to 10.8 percent. Algeria, the Arab Republic of Egypt, the Islamic Republic of Iran, Morocco, Qatar, and Saudi Arabia (counting nationals only) have all seen large drops in unemployment. Employment growth in MENA has been 50 percent higher than in Latin America—and more than twice that in other developing regions (figure 1.1).

The private sector has become more important in recent job growth. In countries where employment data can be disaggregated, the private sector has accounted for about 20 percent of all net job creation, mostly in construction and public-works programs.

Less encouraging are the kinds of jobs created. In general, Middle Eastern countries have not made the dynamic shifts that occurred, for in-

FIGURE 1.1

The Middle East Is Outstripping Other Developing Regions in Creating Jobs and Cutting Unemployment

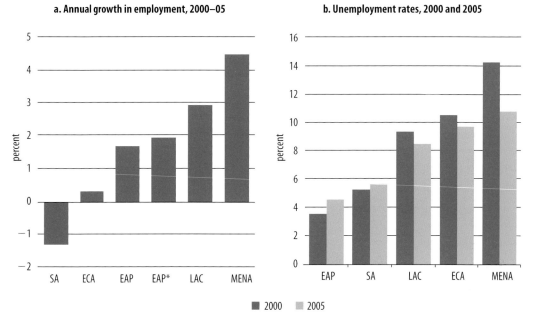

Source: World Bank 2007d.

Note: EAP = East Asia and Pacific; ECA = Europe and Central Asia; LAC = Latin America and the Caribbean; MENA = the Middle East and North Africa; SA = South Asia.

stance, in Ireland in the 1990s, where the sectors with the highest pro-
ductivity gains also produced relatively more jobs, leading to rapid
growth, declining long-term unemployment, and rising standards of liv-
ing. By contrast, job growth from construction and public works is main-
ly cyclical and does not provide sustainable and high-quality jobs over the
longer term. People working in such jobs are not likely to be more suc-
cessful in joining the conventional labor market than before, risking a re-
turn to the pool of unemployed when the job ends (World Bank 2007d).

The picture for women is similarly mixed. Progress in education has
been impressive, and women outnumber men at universities in 11 coun-
tries of 18. Disparities in literacy, primary enrollment, and secondary en-
rollment have fallen dramatically since 1970. More women are now en-
tering the labor market—as a result of rising education, falling fertility,
and growing economies. Over 2000–05 the female labor force grew by
5.2 percent, compared with 4.7 percent during the 1990s. Women's share
in the labor force grew from 25 percent to 27 percent, and women ac-
counted for 36 percent of new entrants in the labor market in 2005, up
from 32 percent in the 1990s. Female employment grew from 10 percent
to 16 percent over 2000–05. Meanwhile, men's labor force participation
stagnated (figure 1.2).

But female unemployment is high and rising, partly the result of
women's growing labor force participation, though the Middle East still
lags behind other regions (figure 1.3). It has increased in 7 countries of
10, rising relative to that of men in all countries except Algeria and the
United Arab Emirates. In Bahrain, the Islamic Republic of Iran, Jordan,

FIGURE 1.2

Rising Labor Force Participation for Women

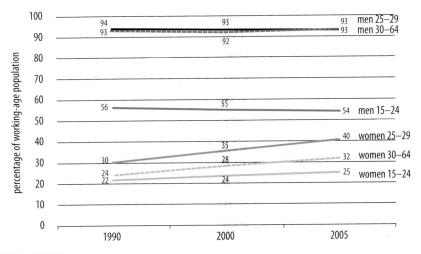

Source: World Bank 2007d.

FIGURE 1.3

Female Labor Force Participation Is Lower in the Middle East and North Africa than Elsewhere, 2005

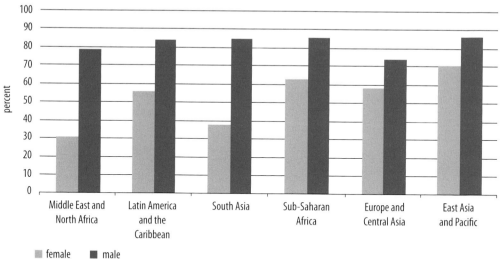

Source: World Bank central database 2006.

and Tunisia female unemployment has increased while that of men has fallen. In the Islamic Republic of Iran and Jordan, it is now about twice that of men. In Egypt, unemployment for women, though declining, is four times that for men—the largest gap in the region. Better news comes from Morocco and Algeria, where female unemployment has fallen, less than male unemployment in Morocco (mainly because of women's falling participation rates) and more in Algeria (reflecting the inclusion of the "work-at-home" sector in the reporting; World Bank 2007d).

Unemployment is highest among the most educated. For women, secondary and higher education is consistently associated with higher unemployment. The falling importance of public employment—more appealing to women than men—is a key explanation for the limited success of educated women despite economic growth (Assad 2006).[1] These trends also suggest that the jobs created could be in sectors or locations not easily accessible for women, such as in construction or public works.

The Challenges

To become more diversified and globally competitive, countries in MENA must address three challenges. The most important challenge has two parts—creating more jobs and creating better jobs. The labor force will reach an estimated 174 million by 2020, so the region will have to

create 54 million jobs over the next 15 years just to keep up. With unemployment now estimated at just above 12 percent,[2] the more ambitious goal of creating jobs for the unemployed will take 68 million new jobs by 2020, or 4.5 million jobs a year. And to boost incomes, meet rising expectations, and avoid mounting social discontent, these jobs must be of high quality.

The second challenge is diversifying the economy by building a new class of entrepreneurs, innovators, and risk takers, creating an environment where private investment and employment can prosper outside the traditional sectors of oil and agriculture, thus reducing the region's dependence on natural resource rents. The need is to move into sectors that can provide more and better jobs for young people—sectors that are more export oriented, labor intensive, and knowledge driven.

The third challenge is empowering women. Women's rising education level has created a resource for development, but high unemployment among educated women means that this resource is underutilized. More opportunities for success in formal employment can benefit women—and the economy as a whole.

Female Entrepreneurs Can Become an Engine of Growth

The Middle East is already benefiting from female entrepreneurship, rooted in a long tradition of women doing business (see annex 1A to this chapter). There is room for expansion.

Across regions and eras, the quality of entrepreneurship makes a major difference in economic growth, explaining much of the difference between developed and developing economies (Schumpeter 1975). A robust entrepreneurial climate—integral to an innovative, adaptable, and growing private sector—needs to include all potential players. Female entrepreneurship can also be important for economic diversification. The data show that as more women entrepreneurs enter the economy, greater economic diversity follows.

The gender deficit in entrepreneurship, a challenge everywhere, is particularly important in the Middle East. Women's entrepreneurship could help the region meet its challenges, because empowering women and diversifying the economy can go together—and help the region meet the critical challenge of creating more and better jobs. By contributing new ideas, technologies, and production methods, these businesses can boost productivity growth across the economy, even spurring existing firms to raise their productivity.

Countries across the world are benefiting from female entrepreneurship. During the 1990s, the number of female-owned businesses in the

United States increased 16 percent, more than 2.5 times the rate of establishment of new businesses generally. In the United Kingdom, female-owned businesses made up a quarter of new businesses during the late 1990s, and growth was substantial in France, Germany, and Italy as well (UNECE 2002). More female entrepreneurs increase economic diversity (Verheul, Van Stel, and Thurik 2006).[3]

Consider, for example, the 20 percent productivity gap between the United Kingdom and the United States. The UK Department of Trade and Industry traced the productivity gap to slower business formation. The rate of business formation by male entrepreneurs is roughly the same in the United Kingdom and the United States. But the gap in the rate of business formation by women entrepreneurs is large—and about the same magnitude as the productivity gap (figure 1.4; World Bank 2006g).[4]

Women's entrepreneurship can be a valuable tool for promoting gender equality and empowering women, helping to achieve the third Millennium Development Goal. Middle Eastern countries have achieved important results in reducing gender disparities in education and human capital investments. Female enrollment in all levels of schooling rose significantly in the years since 1998, with notable gains in secondary school enrollment, showing the high responsiveness of education to gender-informed policy interventions (World Bank 2007c). Advances have been more modest, however, in gender equality in the economy and society. Greater women's participation in the economy through women's entrepreneurship can bring more women into leadership positions in society.

FIGURE 1.4

Can Gender Gaps in Entrepreneurship Lead to Productivity Gaps?
(United Kingdom = 100)

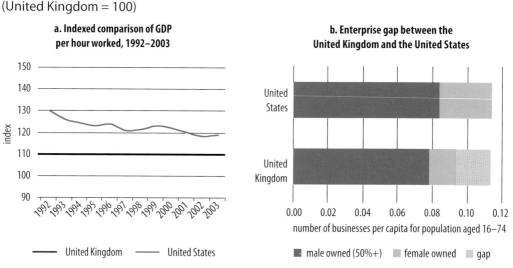

Source: UK Department of Trade.

How the Report Is Organized

This report is different in two ways from previous studies that have surveyed women entrepreneurs. First, it examines the environment for entrepreneurship in greater detail, going beyond gender-neutral business and investment laws to investigate attitudes, procedures for opening and closing businesses, and laws outside business and commerce, assessing whether such factors have gendered effects on women entrepreneurs. Second, it examines male- and female-owned firms, rather than relying on surveys of women entrepreneurs themselves. It identifies investment climate barriers and examines whether male- and female-owned firms perceive them differently.[5]

Chapter 2 employs data from the World Bank's Enterprise Surveys to detail the characteristics and performance of female-owned firms in the region, comparing them with male-owned firms and with other regions. It finds that female-owned enterprises are more widespread, larger, older, and more globally open than expected.

Chapter 3, also based on the Enterprise Surveys, compares how key constraints to business operation and growth affect female-owned enterprises and male-owned enterprises. It assesses the severity of such constraints and (when possible) the existence of objective obstacles to business. It finds that only some elements of the investment climate in MENA are gender-biased, and those are only in some countries. Differences between male- and female-owned firms, however, are critical in Lebanon and the Republic of Yemen.

Chapter 4 draws on World Bank Doing Business data and the World Values Survey (WVS) to identify the underlying causes of the gender-based differences in the ways in which female entrepreneurship is viewed, encouraged, and influenced by social attitudes. It finds that most business laws are gender neutral but that social norms and traditions, facets of the business environment, and discriminatory laws and regulations outside business law may limit the growth of female entrepreneurship and the success of female entrepreneurs.

Chapter 5 offers policy recommendations, arguing that gender-intelligent reforms in the business environment will benefit women entrepreneurs and open new channels for empowering women in the Middle East and boosting economic growth.

Annex 1A. Historical Perspective on Women's Economic Activity in the Middle East and North Africa

In nearly all societies, the gender division of labor associates women with family maintenance. Overwhelmingly, gender segregation and domestic subsistence production have characterized the lives of women in the economic sphere, although before industrialization there was little distinction between the private and public economic spheres, as most production took place in the family and in and around the home (Johnson-Odim and Strobel 1999: xiv–xvii).

In pre- and medieval-Islamic society, women engaged in a variety of economic activities in agriculture, craft and textile production, the tending of livestock, trade, and other areas. In fact, many women engaged in economic activity that not only supplied subsistence but also generated wealth, especially in agricultural and trade sectors of the economy. In some cases, women were engaged in trade that included the large-scale buying and selling of commodities. One such example is Khadija, the first wife of the Prophet Mohammed, who was a renowned and wealthy businesswoman—though by no means the only one of her time—and incontestably an important female role model in Islam. Even where women engaged in local, small-scale trade, they could be very important to the growth and development of long-distance trade and of port towns and urban centers (Nashat and Tucker 1999: 73–84).

Because Islamic law permits women to inherit and independently own property, women of the middle class often had property and engaged in various business activities, such as selling and buying real estate, renting out shops, and lending money at interest. A host of evidence attests to these activities. Studies of women in 16th and 17th century urban centers of the Ottoman Empire, 18th century Aleppo, and 19th century Cairo show that they inherited in practice, not merely in theory, and they were able and willing to go to court if they thought themselves unjustly excluded from inheriting estates (Ahmed 1992: 63).

The absence of male heirs or widowhood could also create economic opportunity for women. Under such circumstances women ran businesses and participated in trades. In Syria the *gedik*, a license that allowed one to practice a trade, was normally inherited by sons from their fathers. In the absence of a male heir, women could inherit the *gedik*, and although prevented from practicing the trade, they could sell, rent, or bequeath the license (Ahmed 1992: 110).

Other forms of investment included making loans at interest, often to family members, frequently to husbands, and sometimes to other women. Such loans were secured in court, and if necessary, women went to court to reclaim them, whether from husbands or other family members or

from anyone else. Suers or sued, women represented themselves in court and their statements had equal weight with men's (Ahmed 1992: 111).

Whereas very wealthy women might invest in trade—often the spice trade—or in commercial ventures as silent partners, middle-class women apparently invested largely in real estate. The pattern of women's involvement in property in the region shows their consistent involvement in real estate. In Aleppo and in Kayseri, women were involved in 40 percent of all property transfers. They actively bought and sold commercial as well as residential property. They probably rented out shops (as women shopkeepers were rare). In Aleppo, a third of those dealing in commercial property were women, and a third of these were buyers (Ahmed 1992).

Residence in a harem and the practice of seclusion placed restraints on women's ability to engage directly in public-arena economic activity, forcing them to use intermediaries to conduct their business operations. This use of intermediaries, and the higher economic status that seclusion usually implied, meant women sometimes held considerable wealth and became significant economic actors. In the 19th century in parts of the Middle East (notably Cairo, Istanbul, Aleppo, and Nablus), upper-class women employed agents to conduct their business transactions in the public arena.

In some places, however, the strict gender segregation of Islamic societies in fact expanded women's economic alternatives because only women could perform certain services for other women. In 19th century Egypt, women of lower economic status served as entertainers, cosmologists, and midwives to women of higher economic status who were in seclusion. Strict gender segregation opened up the professions (medicine, education, and the like) to women in the late 20th century, especially in countries where economic resources are plentiful, such as Saudi Arabia (Ahmed 1992).

Women also undertook various kinds of manufacturing activities. In 18th and 19th century Egypt, women were important in the textile crafts, though they were squeezed out by industrialization. In the 19th century, partially because of the demand created by a European market, women became important to the growth of the silk industry in Lebanon and in the carpet industry in Iran. Yet, women's tremendously varied and important roles in economic activity did not translate into economic, legal, or political equality with men. The more economic autonomy women had, however, the greater their freedoms. In some writings, though, elite urban men were cautioned not to marry women who engaged in economic activities in the public arena (Ahmed 1992).

The sweeping economic transformations of the 19th century—including the commercialization of agriculture and erosion of the indigenous craft industry as a result of European competition or outright con-

trol of local economies—held special implications for women and the family. Much of the historical literature on the period, however, insofar as it alludes to women at all, emphasizes one of two points about the impact of the economic transformation. First, many authors simply have assumed that women and the family were largely untouched by the economic changes of the period: women remained in the inviolate world of harem or in the "traditional" confines of the peasant family, pursuing an existence on the margins of economic life, making few contributions outside of the admittedly often strenuous work performed in the home. Second, this pattern of female marginality was disrupted by modernization and westernization: women began to undertake broader economic activities, to enter the professions or the working class, for example, only in the context of westernization and industrialization of the late 19th and 20th centuries. Both of these points have come under close scrutiny recently, and studies of women's economic activities in the 19th century now suggest the complexity of women's roles in the pre-capitalist era and contest the idea that 19th century developments brought automatic improvements (Nashat and Tucker 1999).

Notes

1. The public sector is often preferred by young women because of such benefits as maternity leave, childcare facilities, and flexible work hours. The wage premium for public sector jobs relative to private sector jobs tends to be higher for women than for men. And in Egypt, for example, the gender wage gap has been smaller in the public sector than in the private (World Bank 2004a, 2004b).
2. For the 12 countries of the MENA region and Iraq, Lebanon, and the Republic of Yemen, for which there are point estimates.
3. The Global Entrepreneurship Monitor's Report on Women and Entrepreneurship (Allen, Langowitz, and Minniti 2006: 8) finds little evidence to support the hypothesis that women and men may open different types of businesses, with different structures, in different sectors, selling different products, and ultimately chasing different outcomes and that "women's businesses show many of the same patterns as those of their male counterparts, in particular [t]he distribution of women entrepreneurs across broad industrial sectors... is comparable to those of men." Because they are in the same sectors as male-owned businesses, this is good for the overall competitive environment, leading to greater efficiency and productivity.
4. Discovering that the productivity gap was essentially a gender gap, policy makers enacted measures to support greater female entrepreneurship.
5. The analysis is based on survey data collected at the firm level. As a result, neither the person who completed the survey nor that person's gender are identified.

Female-Owned Firms Defy the Expected

Women entrepreneurs are a minority everywhere, but in the Middle East and North Africa (MENA), just 13 percent of firms are owned by women, significantly fewer than in East Asia and Pacific, Latin America and the Caribbean (LAC), or Europe and Central Asia (ECA) (figure 2.1). The share of female-owned firms in MENA varies significantly across the region, however—from nearly 30 percent in Lebanon and 20 percent in the Arab Republic of Egypt and the West Bank and Gaza to just 10 percent in Morocco and the Syrian Arab Republic (figure 2.2).

Even so, female-owned firms defy commonly held expectations. This chapter employs data from the World Bank's Enterprise Surveys to detail

FIGURE 2.1

Female-Owned Firms Are Relatively Rare in the Middle East

(female-owned firms as a percentage of all firms)

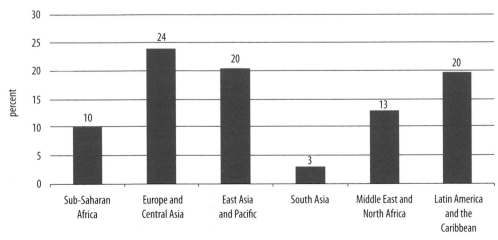

Source: World Bank Enterprise Survey data, 2003–06.

11

FIGURE 2.2

The Share of Female-Owned Firms Varies across the Region

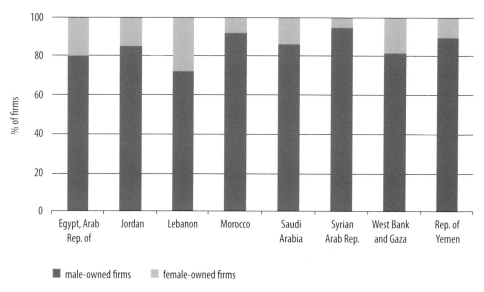

Source: World Bank Enterprise Survey data, 2003–06.

the characteristics and performance of female-owned firms in the region, comparing them with male-owned firms and with other regions (see annex 2A for details on data and methodology). It finds that female-owned enterprises are more widespread, larger, older, and more globally open than expected.

More Women Are Individual Owners Than Expected

The share of women in MENA owning their firms individually instead of as part of a family is higher than expected (figure 2.3). In Syria and the Republic of Yemen, most women own their firms individually, at rates comparable with male individual ownership. The rates are lower in Morocco, but still on par with those of men. In Egypt, Lebanon, and Saudi Arabia, however, the proportion of female-owned firms owned individually is significantly lower than that of male-owned firms.

In Morocco and Syria more than 65 percent of female business owners are also managers of their enterprises, debunking the myth that women are owners in name only. In other countries the data do not allow determining whether male- or female-owned firms are managed by the owner.

FIGURE 2.3

Enterprises Owned Individually, by Gender of Owner

(percent)

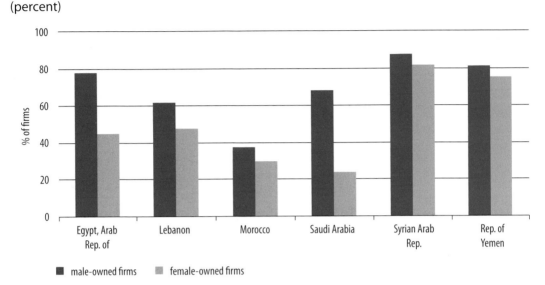

Source: World Bank Enterprise Survey data, 2003–06.

Note: Information about whether the enterprise is individually or family-owned is not available for Jordan and the West Bank and Gaza.

Female-Owned Firms Are Large and Well-Established

Contrary to expectations, female-owned firms are not relegated to the ranks of micro or small enterprises. Although most firms in MENA, whether male- or female-owned, are small, women are more likely than men to own large firms (table 2.1).[1]

Female-owned firms are well-established. The average age of female-owned firms is slightly higher than that of male-owned firms—21 years across the region, compared with 18 years for male-owned firms.[2]

Firm size and years of market experience are important for assessing performance, productivity, and firms' relationships with the business environment. Although large firms typically do not grow as quickly as smaller firms, they are more likely to survive. Large firms are also better able to access technology and benefit from economies of scale. Larger firms can attract a more skilled workforce because they can often pay higher salaries and provide greater job security. So, the fact that male- and female-owned firms in the region have similar size and age distributions indicates that these factors do not explain why there are not more female-owned firms. Considering enterprise size and age as proxies of enterprises' ability to deal with the market implies that female-owned firms, once

TABLE 2.1

Distribution of Male- and Female-Owned Firms, by Size and Average Years of Experience

Country	Micro (1–9 employees) Male-owned firms	Micro Female-owned firms	Small (10–49 employees) Male-owned firms	Small Female-owned firms	Medium (50–99 employees) Male-owned firms	Medium Female-owned firms	Large (100+ employees) Male-owned firms	Large Female-owned firms	Years in business Male-owned firms	Years in business Female-owned firms
Egypt, Arab Rep. of	4.9	4.4	52.1	45.0	8.2	8.8	34.8	41.9	21.3	21.9
Jordan	17.1	5.4	44.5	52.7	14.5	12.2	23.9	29.7	14.5	15.1
Lebanon	9.2	9.8	64.1	60.9	13.5	9.8	13.1	19.6	28.4	30.7
Morocco	0.0	0.0	47.7	36.4	17.8	22.7	34.5	40.9	17.7	17.0
Saudi Arabia	0.6	0.0	41.6	27.4	28.1	32.3	29.8	40.3	18.7	23.4
Syrian Arab Rep.	29.3	29.6	50.8	55.6	11.8	7.4	8.1	7.4	15.6	18.7
West Bank and Gaza	35.1	31.9	51.8	45.8	8.2	11.1	4.9	11.1	16.4	18.6
Yemen, Rep. of	44.6	52.4	32.6	23.8	10.9	4.8	12.0	19.1	13.6	18.8

Source: World Bank Enterprise Survey data, 2003–06.

established, seem to be at least as able as male-owned firms to stay in the market, become more experienced, and grow.

The distribution of female-owned firms across sectors is roughly the same as that of male-owned enterprises (table 2.2). Some slight differences emerge across countries. In Morocco and Syria, women are more likely than men to own textile firms, while in Saudi Arabia they are disproportionately likely to own agro-food firms. In the West Bank and Gaza they are more likely to own service enterprises.

Male- and female-owned firms also differ little in their location. Except in Egypt and the Republic of Yemen, about half of firms—both male- and female-owned—are located in the capital cities. In Egypt, where the proportion of firms located in the capital is lower than for the region overall, female-owned firms are more likely to be located in Cairo. In the Republic of Yemen, female-owned firms are significantly less likely to be located in the capital.[3]

Sources of finance differ little by the gender of the firm owner. For both male- and female-owned firms, nearly 80 percent of new investments and working capital are financed by internal funds or retained earnings. Commercial banks and other formal sources, such as leasing arrangements, investment funds, or credit cards, account for 10 percent of funding. Informal sources account for only 4 percent. The remaining 6 percent is funded by other sources.

Some gender-based differences appear in Jordan. There, about 14 percent of female-owned firms' new investments are funded by commercial banks or other formal financial sources, compared with only 4 percent for

TABLE 2.2

Distribution of Male- and Female-Owned Firms, by Sector and Location

	Sector (percentage of all enterprises of relevant gender ownership)								Located in the capital (percent)	
	Textile		Agro-food		Other manufacturing		Services			
Country	Male-owned firms	Female-owned firms	Male-owned firms	Female-owned firms	Male-owned firms	Female-owned firms	Male-owned firms	Female-owned firms	Male-owned firms	Female-owned firms
Egypt, Arab Rep. of	32.7	32.7	12.7	15.7	53.5	50.3	1.2	1.3	*19.6*	*28.8*
Jordan	19.7	18.9	18.0	21.6	31.2	37.8	23.9	17.6	—	—
Lebanon	16.4	15.2	15.6	12.0	20.2	25.0	39.5	42.4	52.1	48.9
Morocco	*68.8*	*86.4*	*8.4*	*2.3*	*22.8*	*11.4*	—	—	64.1	59.1
Saudi Arabia	—	—	11.3	25.4	79.3	66.7	—	—	47.3	47.6
Syrian Arab Rep.	41.3	63.0	17.8	14.8	40.1	22.2	0.2	—	—	—
West Bank & Gaza	*7.6*	*8.3*	*17.4*	*9.7*	*57.3*	*56.9*	*9.8*	*20.8*	—	—
Yemen, Rep. of	—	—	—	—	23.9	33.3	76.1	66.7	*30.5*	*12.5*

Source: World Bank Enterprise Survey data, 2003–06.

Note: — = data are not collected in the survey. Differences are tested by chi-squared test. Italicized numbers indicate differences that are statistically significant at the 5 percent level.

male-owned firms. Jordan's female-owned firms, however, rely significantly more than male-owned firms on informal funds. For both male- and female-owned firms the bulk of new investment financing is provided by internal funds and retained earnings. A similar picture emerges when the main sources of finance for working capital are considered (figure 2.4).

In Lebanon, male- and female-owned firms seem to have better access to finance than other firms in the region. On average, about 40 percent of both new investments and working capital are funded by commercial banks or other formal sources of finance, and only 50 percent by internal funds or retained earnings (figure 2.4).

The heavy reliance on internal funds indicates that across MENA, both male- and female-owned firms have little access to developed financial markets, even as established firms. Having access to lenders and investors means that entrepreneurs in firms of all sizes can seize promising investment opportunities on a more timely basis than if they relied on internally generated cash flow and money from family and friends (World Bank 2005c).

Inadequate access to finance is a key issue in MENA, as in other developing regions. For existing firms, it does not seem to be related to the gender of the owner. Because female-owned firms are as large and as old as male-owned firms, they are not considered a greater risk by banks. Access to finance may well be different for male and female start-ups, but this possibility could not be evaluated using the current data.

FIGURE 2.4

Sources of Finance for New Investment in Jordan and Lebanon, by Gender of Owner

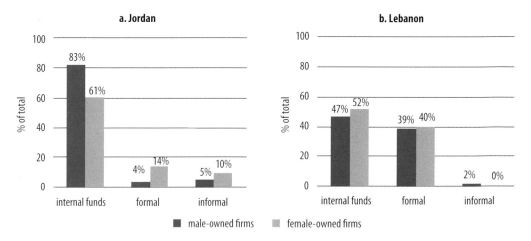

Source: World Bank Enterprise Survey data, 2006.

Female-Owned Firms Participate in the Global Economy

Male- and female-owned firms have similar patterns of domestic sales, selling most products to small domestic firms or individuals. Their global orientation—participation in export markets, use of information and communication technology, and attraction of foreign direct investment—is also similar, though female-owned firms have an edge.

In Egypt, Jordan, and Morocco female-owned enterprises are significantly more likely than male-owned enterprises to export (figure 2.5).[4] Female-owned firms in Morocco have much more foreign investment.[5] This strong export performance suggests that female-owned firms are productive—only efficient firms can compete in the international market. The export success of female-owned firms may also be linked to their size, which helps them achieve economies of scale.

Male- and female-owned firms are quite similar in their use of e-mail and Web sites for interacting with clients and suppliers. However, female-owned firms in Egypt, Jordan, Morocco, and the West Bank and Gaza more regularly use the Web than do male-owned firms. The high export rates and high e-mail use rates are closely linked. For instance, controlling for other structural characteristics (size, sector of activity, firm experience, and location), being an exporter increases the probability of using e-mail by 37 percentage points in Egypt, by 33 percentage points in Jordan, and by 21 percentage points in Morocco. In the West Bank and Gaza, however, the regular use of e-mail is mainly influenced by enterprise size and sector of activity.

FIGURE 2.5

Global Orientation of Male- and Female-Owned Firms

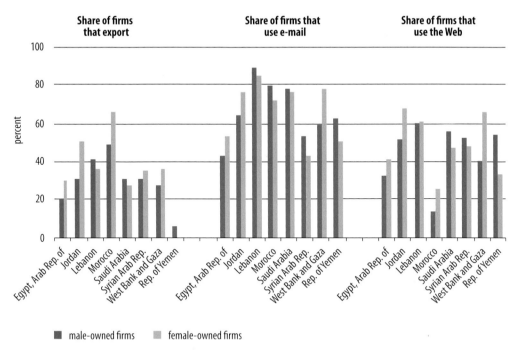

■ male-owned firms ■ female-owned firms

Source: World Bank Enterprise Survey data, 2003–06.

Note: Differences are statistically significant (at the 5 percent level) only for Egypt and Morocco.

Women Employ More Educated Workers and More Women

Workers in female-owned firms are as educated and as skilled as those in male-owned firms (tables 2.3 and 2.4). Except in Lebanon and Saudi Arabia, female-owned firms employ more women than do male-owned firms (figure 2.6). This is true not only in Morocco and Syria, where female-owned enterprises are most prevalent in the traditionally female textile sector, but also in Egypt and the Republic of Yemen, where male- and female-owned firms are distributed similarly across sectors.

Female-owned firms in Egypt and Morocco not only hire a higher proportion of female workers than do male-owned firms, but they also employ a higher share of female workers at professional and managerial levels. This finding is particularly relevant given the high unemployment of highly educated women in the region. Promoting female entrepreneurship can thus be a tool for fostering women's participation in the labor market and for reducing the unemployment of highly educated women.

TABLE 2.3

Workforce Composition, by Education

(percentage of all workers of the relevant gender ownership)

| Country | Fewer than 6 years | | 7–12 years | | More than 12 years | |
	Male-owned firms	Female-owned firms	Male-owned firms	Female-owned firms	Male-owned firms	Female-owned firms
Egypt, Arab Rep. of	*12.9*	*15.7*	*70.0*	*66.4*	17.1	17.9
Jordan	29.8	20.7	65.4	70.7	4.9	8.6
Lebanon	6.7	6.0	61.5	66.6	31.6	26.9
Morocco	40.5	41.8	51.7	48.7	7.7	9.5
Saudi Arabia	11.7	12.6	62.8	64.9	25.6	23.6
Syrian Arab Rep.	—	—	—	—	—	—
West Bank and Gaza	—	—	—	—	—	—
Yemen, Rep. of	—	—	—	—	—	—

Source: World Bank Enterprise Survey data, 2003–06.

Note: — = data are not collected in the survey. Differences are tested by a t-test. Italicized numbers indicate differences that are statistically significant at the 5 percent level.

Saudi Arabia is an anomaly in the sample—with female workers making up less than 1 percent of both male- and female-owned firms. In addition, Saudi firms are more likely than firms in other countries to identify labor regulations as a constraint to business operation and growth (see chapter 3). This finding, together with the large difference between male- and female-owned firms in terms of individual ownership (see figure 2.3), suggests the need for caution in drawing conclusions about whether Saudi Arabian women manage the firms they own. The data, however, do not currently allow this question to be investigated.

TABLE 2.4

Workforce Composition, by Skill Level of Position

(percentage of all workers of the relevant gender ownership)

| Country | Nonproduction | | Unskilled | | Skilled | | Professional | |
	Male-owned firms	Female-owned firms	Male-owned firms	Female-owned firms	Male-owned firms	Female-owned firms	Male-owned firms	Female-owned firms
Egypt, Arab Rep. of	*9.9*	*12.1*	*28.1*	*25.8*	*45.8*	*43.2*	*16.5*	*19.1*
Jordan	—	—	29.1	33.0	41.5	38.1	29.0	28.8
Lebanon	—	—	34.2	34.6	36.8	37.5	28.9	27.2
Morocco	*7.6*	*4.8*	43.0	43.6	40.5	43.2	8.7	8.4
Saudi Arabia	15.7	15.6	32.3	34.7	*34.4*	*30.8*	17.2	17.8
Syrian Arab Rep.	7.7	8.1	33.6	36.0	33.1	36.3	25.6	19.6
West Bank and Gaza	—	—	—	—	—	—	—	—
Yemen, Rep. of	—	—	—	—	—	—	—	—

Source: World Bank Enterprise Survey data, 2003–06.

Note: — = data are not collected in the survey. Differences are tested by a t-test. Italicized numbers indicate differences that are statistically significant at the 5 percent level.

FIGURE 2.6

Female Workers Hired in Male- and Female-Owned Firms

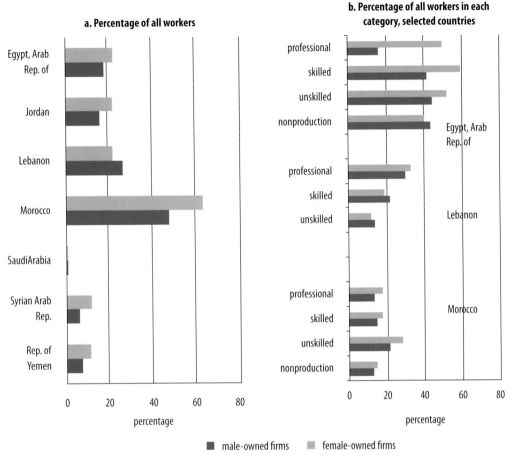

Source: World Bank Enterprise Survey data, 2003–06.

Note: Differences are tested by a t-test. Differences in the percentage of female workers in the total workforce are always statistically significant. Differences in the percentage of female workers in the different categories are statistically significant in Egypt (at the 5 percent level) and in Morocco (at the 1 percent level).

Finally, female-owned firms are hiring more workers in general. Except in the Republic of Yemen, the direction and the extent of workforce changes in female-owned firms is as good as or better than that in male-owned firms (figure 2.7).[6] In Egypt, Jordan, Saudi Arabia, and the West Bank and Gaza, the share of female-owned firms that have increased their workforces recently exceeds the share of male-owned firms that did so, and fewer female-owned firms than male-owned firms have decreased their workforces.

In Morocco and Syria, female-owned enterprises were also more likely than male-owned enterprises to increase their formally hired workforces. In both countries, however, this gain was almost offset by the

FIGURE 2.7

Female-Owned Firms Are Hiring More Workers in Egypt, Jordan, Saudi Arabia, and the West Bank and Gaza

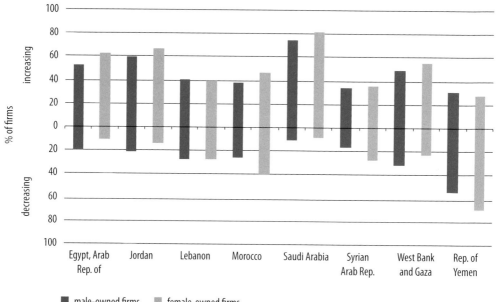

■ male-owned firms ■ female-owned firms

Source: Staff estimates based on Enterprise Survey data.

Note: Data refer to the percentage of enterprises increasing or decreasing their workforces between 2001 and 2000. Data for the West Bank and Gaza refer to 2001 and 1999. The upper point of each bar reports the percentage of firms that increased their workforces, and the percentage of firms decreasing their workforces is reported by the lower point.

higher proportion of female-owned enterprises that reduced their workforces. In Lebanon, results were broadly similar for male- and female-owned enterprises. In the Republic of Yemen, female-owned firms did less well. True, female-owned firms were more likely than male-owned firms to hire new workers, but female-owned firms also saw an overall decline in workers. About 70 percent of female-owned enterprises cut their workforces, compared with less than 60 percent of male-owned enterprises.

Female- and Male-Owned Firms Have Similar Productivity

The productivity of female-owned firms, measured by sales and value added per permanent worker, compares well with that of male-owned firms where data are available (figure 2.7). Larger differences (though still small in magnitude) occur only in Morocco and Saudi Arabia. The distribution of firms across sectors may partly explain these differences.

Female-owned firms in these countries are concentrated in textiles and agro-food manufacturing (see table 2.2), sectors traditionally character-ized by low value added. Differences in sales per permanent worker are very small across countries.

FIGURE 2.8

Productivity Differences between Male- and Female-Owned Firms

(advantage for male-owned firms, 2004 US$ thousands, median value)

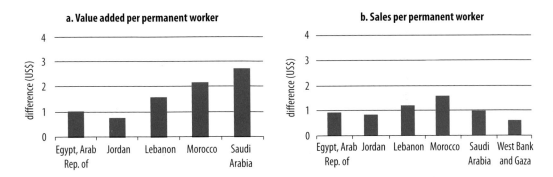

Source: World Bank Enterprise Survey data, 2003–06.

Note: Data are unavailable for Syria and the Republic of Yemen. Data for the West Bank and Gaza pertain only to sales.

Annex 2A. Data and methodology

The analysis in chapters 2 and 3 is based on the World Bank's Enterprise Surveys, which include more than 26,000 firms in the formal manufacturing and services sectors in 53 developing countries. The surveys identify the main features of firms—type of ownership, size of the enterprise, sector of operation, years of market experience, composition of the workforce, and performance in the economy. In some countries the data can be disaggregated by the gender of the owner.

More important for this report, firms are asked to rate their perception of the investment climate along 18 categories, rating constraints as minor, moderate, major, or severely binding.[7] For some barriers the survey has subsequent questions about the actual occurrence of events that support the perception (referred to here as the objective response). On electricity as a constraint, for example, firms provided details about the frequency of black-outs and surges and the revenue lost because of them.

In MENA, gender-disaggregated surveys cover 4,832 enterprises in the Arab Republic of Egypt, Jordan, Lebanon, Morocco, Saudi Arabia, the Syrian Arab Republic, the West Bank and Gaza, and the Republic of Yemen.[8]

The data have some limitations. First, the sample sizes are small and the dataset does not allow for weighting. Caution is thus needed in drawing general conclusions about the entire population of enterprises in the region. Second, the sample may be affected by selection effects. Given the binding entry barriers, firms currently operating are likely to be among the better performers and may have a better perception of the investment climate or more experience in how to navigate it. This is true for both male- and female-owned firms, but female-owned firms might be more affected by the selection effect because the business environment is generally more discouraging for women (see chapter 4). However, this

TABLE 2A.1

Sample Composition of World Bank Enterprise Survey Data for the Middle East and North Africa

Country	Year	Observations
Egypt, Arab Rep. of	2006	996
Jordan	2006	503
Lebanon	2006	354
Morocco	2004	850
Saudi Arabia	2005	681
Syrian Arab Rep.	2003	560
West Bank and Gaza	2006	401
Yemen, Rep. of	2004	487

Source: World Bank Enterprise Survey data, 2003–2006.

bias may be partially offset by a self-selection effect. Firms that perceive the investment climate as more binding may be more willing to spend time answering a survey than those that perceive it as less binding.

Nor do the data provide information on whether the enterprise was founded by the owner or whether the owner acquired the enterprise through inheritance or purchase. Also lacking are consistent data for all the countries on whether the firms are managed directly by the owner or whether the owner is mainly an investor. Data are about only a specific point in time and do not allow analyzing changes over time or how many enterprises have been created or closed in each country.

The analysis of enterprises' characteristics and their relationship with the investment climate was carried out in two steps. The variables' frequency distributions were examined first. Differences between male- and female-owned firms were tested by binary tests. The hypothesis tested was that there is no relationship between the gender of the enterprises' owners and their characteristics or perceptions of investment climate barriers. Whenever possible, the robustness of the results was checked by multivariate analysis controlling for female ownership, size (number of workers employed), location (whether the enterprise is located in the capital city), sector of activity (textile, agro-food, other manufacturing, or services), experience in the market (logarithm of years of activity), and managerial skills (logarithm of the years of education for the top manager). Given endogeneity problems, however, no strong causal link can be attributed to the findings of the multivariate analysis. Even so, it offers a valuable and workable tool for checking the robustness of the results from the descriptive analysis.

Notes

1. In this report, firms are classified according to the following definition: micro (1–9 employees), small (10–49 employees), medium (50–99 employees), large (100 or more).
2. A t-test confirms that the difference between the average age of female-owned firms and the average age of male-owned firms is statistically significant. This result was checked by estimating a linear regression model, where the dependent variable is the logarithm of the enterprise's age and the controls are the gender of the owner; enterprise size, sector of activity, and location; and a set of country dummy variables. The model confirms that the age of female-owned firms is 10 percent higher than the age of male-owned firms, on average and all other things equal.
3. The absence of substantial differences between male- and female-owned firms is validated by the multivariate analysis, which confirms the existence of significant differences between male- and female-owned firms in only a few cases.

4. Exporters are firms that export more than 10 percent of their output.
5. Firms with high foreign investment are those in which the share of subscribed capital owned by foreign investors is at least 10 percent of the total.
6. This is true for the whole sample of female-owned firms and for female-owned micro and small firms, confirming that once established, female-owned firms perform well, with only insignificant differences by size.
7. For more information on the Enterprise Surveys, see www.enterprisesurveys.org.
8. The World Bank Enterprise Survey data for MENA also include Algeria and Oman. For these two countries, however, gender-disaggregated analysis is not feasible.

Investment Climate Barriers to Female-Owned Firms

Female-owned firms in the Middle East and North Africa (MENA) region are as large, successful, well-established, and tech savvy as male-owned firms, at times even more so. Given their success—and their potential for stimulating economic growth—why are there not more female entrepreneurs in the region? Does the investment climate pose greater challenges for female-owned firms than for male-owned firms?

To answer this question, the report looks at the empirical evidence about the way in which key constraints to business operation and growth affect female-owned firms in MENA compared with male-owned firms—and the way in which the region compares with other middle-income regions.[1]

The analysis in this chapter is on two levels. First, the region's firms' overall perceptions of the 18 investment climate constraints identified by the Enterprise Survey data are compared with the perceptions of firms in other similar middle-income regions—East Asia and Pacific (EAP), Latin America and the Caribbean (LAC), and Europe and Central Asia (ECA). Second, the chapter compares the perceptions of female-owned firms in the Middle East with those of male-owned firms at the level of individual countries, analyzing firm-level perceptions of investment climate constraints as binding for business operation and growth. Binding obstacles are those reported as "major" or "very severe."[2] Data permitting, the analysis also looks at differences between male- and female-owned firms in the occurrence of events that support the perceived constraints (referred to here as objective responses). On electricity, for example, firms provided details about the frequency of black-outs and surges and the revenue lost because of them.

The surprising finding is that the investment climate in MENA is much less gendered than suspected. Female-owned firms perceive the investment climate as only marginally more difficult than do male-owned firms—and in only a few countries and sectors. More striking is the gap

between firm-level responses in the Middle East and those in other regions. Firms in MENA tend to perceive the business environment as more difficult than do firms in other regions, regardless of the owner's gender (in general and acknowledging issues related to aggregation across countries and regions; figure 3.1).

Investment Climate Barriers Are Not Particularly Gendered

Firms in MENA face a binding investment climate, regardless of the gender of the firm's owner. Male- and female-owned firms tend to rate the same investment climate constraints as major and very severe obstacles and the same constraints as minor and moderate obstacles (figure 3.2).

FIGURE 3.1

The Investment Climate Is Binding for Both Male- and Female-Owned Firms in the Middle East and North Africa

(barriers reported by firms as major or very severe constraints)

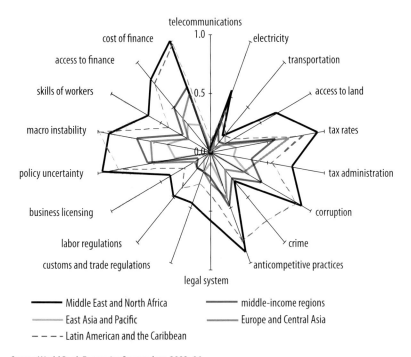

Source: World Bank Enterprise Survey data, 2003–06.

Note: Values are normalized by maximums and minimums for each indicator. The index ranges from 0 (best perception) to 1 (worst perception).

FIGURE 3.2

Perception of the Investment Climate in the Middle East and North Africa, by Gender of the Principal Owner

(percentage of firms citing constraint)

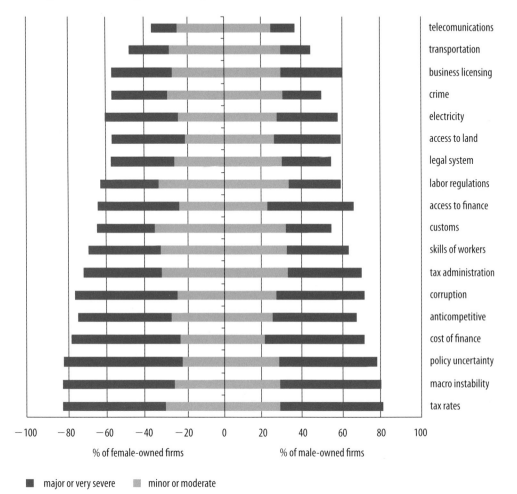

Source: World Bank Enterprise Survey data, 2003–06.

The similar degree of perception of barriers is confirmed at the country level, suggesting that there is no clear (statistically significant) evidence that the investment climate is gendered across all barriers in every country (see annex 3A at the end of this chapter for detailed country-specific results).[3] For no constraint do female-owned firms systematically report a worse perception across all countries in the region. Nor in any country do female-owned firms report all the constraints as more binding than do male-owned firms. Where there are differences, they are not always to the detriment of female-owned firms. In a few cases, female-

owned firms are less likely than their male counterparts to report constraints as major or very severe.

Some differences do emerge, however. The investment climate is more gendered in the Republic of Yemen and Lebanon, where there are statistically significant gender differences across more barriers. This is surprising: the Republic of Yemen and Lebanon are on opposite ends of the spectrum in their social configurations, confessional diversity, degrees of economic and social openness, and, above all, per capita incomes.

In both countries, female-owned enterprises are more likely to perceive as a binding constraint anticompetitive and informal practices. Lebanese female-owned firms also have higher perceptions of crime, corruption, and policy uncertainty as particularly binding obstacles, while in the Republic of Yemen, differences are relevant and statistically significant in perceptions of the legal system, tax administration, customs and trade regulations, and macroeconomic instability. In the Republic of Yemen, access to land, access to finance, and cost of finance are also significantly more often reported as binding constraints by female-owned firms. Differences in a few other constraints are relevant but not statistically significant. Transportation is less often reported as a binding problem in Lebanon and the Republic of Yemen (though only slightly)—an intriguing finding in Yemen because female-owned firms there are less likely than male-owned firms to be located in the capital.

TABLE 3.1

Percentage of Male- and Female-Owned Firms Reporting the Actual Occurrence of Selected Constraints

	Egypt, Arab Rep. of		Jordan		Lebanon	
	Male-owned firms	Female-owned firms	Male-owned firms	Female-owned firms	Male-owned firms	Female-owned firms
Electricity						
Days of power outages or surges from the public grid over the last year	10**	14**	na	na	25	24
Losses of value because of interruption of power outages (% of total sales)	5**	7**	2	3	7	8
Legal system and conflict resolution						
Average weeks needed to resolve disputes related to overdue payments in court	54*	86*	45	—	111	89

Source: World Bank Enterprise Survey data, 2003–06.

Note: — = fewer than 25 observations; na = data are not collected in the survey.
** significant at the 5 percent level.
* significant at the 10 percent level.

Gender-related differences affect the investment climate in the West Bank and Gaza as well, with female-owned firms more likely to perceive binding constraints related to telecommunications, access to land, and the labor force (both labor regulation and the availability of skilled and educated workers). Of interest is the fact that female-owned firms seem to perceive corruption as a less binding obstacle.

There are some gender-related differences in the Arab Republic of Egypt's investment climate. Egyptian female-owned firms are more likely than male-owned firms to perceive access to land and electricity as problems.[4] This finding is confirmed by additional analysis, which substantiates differences for electricity through the objective occurrence of problems. Egyptian female-owned firms report a yearly average of 14 days of interruption from power outages or surges from the public grid, compared with 10 days reported by male-owned firms.[5] It is difficult to explain the root causes. More interesting is that female-owned firms report higher losses because of these problems (7 percent of total sales, compared with 5 percent for male-owned firms). Egyptian female-owned firms also report higher legal constraints. This difference, though not statistically significant, is confirmed by the occurrence of objective obstacles. On average, female-owned firms need 86 weeks to resolve disputes over overdue payments, eight months longer than the 54 weeks for male-owned firms. That difference is statistically significant (table 3.1).

| Morocco | | Saudi Arabia | | Syrian Arab Rep. | | Rep. of Yemen | | West Bank and Gaza | |
Male-owned firms	Female-owned firms	Male-owned firms	Female-owned firms	Male-owned firms	Female-owned firms	Male-owned firms	Female-owned firms	Male-owned firms	Female-owned firms
8	—	6	6	30	29	26	—	na	na
1	—	4	2	9	—	—	—	5	4
45	—	27	29	12	—	43	—	—	—

Moroccan female-owned firms seem to have a harder time finding skilled and educated workers, while in Jordan, female-owned enterprises are more likely to perceive labor regulation and policy uncertainty as binding constraints. By contrast, the responses of male- and female-owned firms in the Syrian Arab Republic are similar, indicating that none of the constraints are significantly gender biased.

An interesting finding is that Saudi Arabia's business environment does not appear to be gendered. This could indicate that the business environment in Saudi Arabia is indeed gender neutral—or that there are no differences between male- and female-owned firms because both are managed by men with mainly male employees, given that the share of female employees in Saudi firms is low. Female-owned firms do, however, still report transportation as a statistically significant barrier. Male-owned firms do not.

A surprising finding is that access to finance, commonly considered a gender-based barrier, is not perceived as any more binding by female-owned firms. This might be because these firms are established and in operation. The data in this report could not be used to analyze whether firm start-up is gender differentiated. Only in the Republic of Yemen do the responses of existing female-owned firms suggest gender-differentiated access to finance. There, the gap is not only statistically significant but also particularly wide (figure 3.3). This finding does not mean that finance is not a considerable barrier to businesses. It just means that male- and female-owned firms face the same high barriers.

FIGURE 3.3

Finance Barriers in the Republic of Yemen, by Gender of the Principal Owner

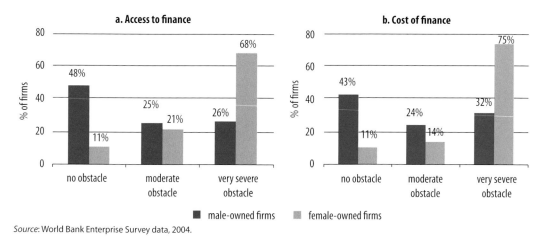

Source: World Bank Enterprise Survey data, 2004.

In some countries (Egypt and Saudi Arabia, for example) female-owned firms deal better than male-owned firms with the tight labor regulations, seeing them as less of a constraint than do male-owned firms. This perception may partly explain why female-owned firms hire more women, who are normally perceived as constraining employers because of a host of gender-specific protective benefits and restrictions. Once again, the results are not consistent across countries. In Jordan and the West Bank and Gaza, labor regulations are more often reported as binding obstacles by female-owned firms.

The Nongendered Business Environment Raises Questions about the Scarcity of Female Entrepreneurs

The findings in this chapter raise their own questions.

The first set of questions concerns the absence of data on the effect of gender on firm start-ups. Although the investment climate for firms in operation is not particularly gendered, whether gender-based barriers hinder starting up new firms is unknown. Generally high barriers discourage all prospective entrepreneurs from starting new businesses in the formal sector—but the barriers may hinder women more. However, women may have some "risk capital"—inheritance or income—because men bear the responsibility for supporting the family. Data are unavailable on how many men and women try to start new businesses and how many succeed, as are data on the impact of barriers to starting, operating, and closing a business. It is thus impossible at present to say whether there are so few female-owned firms in MENA because female entrepreneurs are unable to enter markets or because they find it too difficult to stay in the market once they overcome the high entry barriers.

The second set of questions concerns the effect of social norms. The characteristics and performance of female-owned firms cannot explain why there are not more female entrepreneurs, especially given that the investment climate is not particularly gendered. A similar mystery is evident in female labor force participation. The characteristics of today's women—younger, more educated, and with fewer children—cannot explain why female labor force participation remains lower in the Middle East than in any other regions. A possible explanation for both phenomena is that social norms still create barriers to women joining the labor force and becoming entrepreneurs. The next chapter takes some first steps toward addressing these questions.

Annex 3A. Country-Specific Results on Perceived Investment Climate Barriers

This annex details complete country results on perceived investment climate barriers (figure 3A.1 and table 3A.1).

FIGURE 3A.1

Percentage of Male- and Female-Owned Firms Reporting Investment Climate Constraints as Major or Very Severe Obstacles to Business Operation and Growth

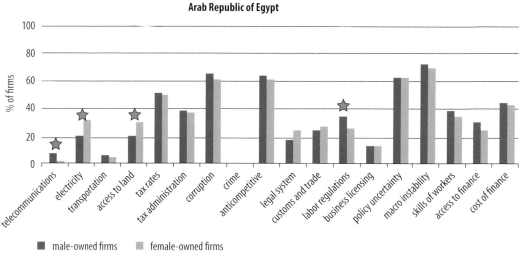

Source: World Bank Enterprise Survey data, 2003–06.

Note: Stars indicate differences that are statistically significant at the 1 percent level or the 5 percent level.
Given the small sample size, it is not possible to determine in countries with a relevant but not statistically significant difference if the result is due to the small sample size or whether it reflects a lack of economic difference between male- and female-owned firms.

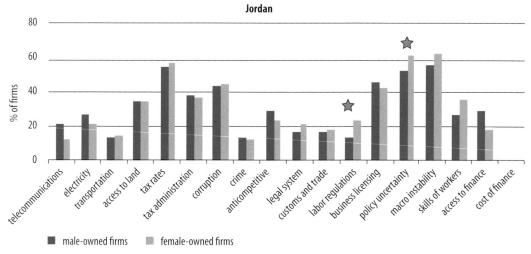

Source: World Bank Enterprise Survey data, 2003–06.

Note: Stars indicate differences that are statistically significant at the 1 percent level or the 5 percent level.
Given the small sample size, it is not possible to determine in countries with a relevant but not statistically significant difference if the result is due to the small sample size or whether it reflects a lack of economic difference between male- and female-owned firms.

FIGURE 3A.1 (continued)

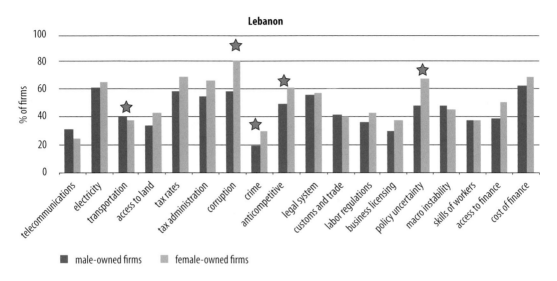

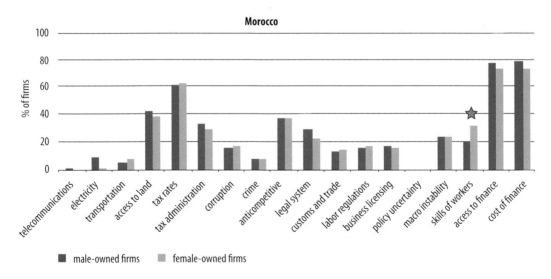

Source: World Bank Enterprise Survey data, 2003–06.

Note: Stars indicate differences that are statistically significant at the 1 percent level or the 5 percent level.
Given the small sample size, it is not possible to determine in countries with a relevant but not statistically significant difference if the result is due to the small sample size or whether it reflects a lack of economic difference between male- and female-owned firms.

(Figure continues on the following pages.)

FIGURE 3A.1 (continued)

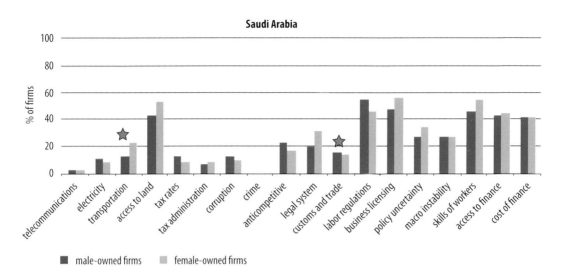

Source: World Bank Enterprise Survey data, 2003–06.

Note: Stars indicate differences that are statistically significant at the 1 percent level or the 5 percent level.
Given the small sample size, it is not possible to determine in countries with a relevant but not statistically significant difference if the result is due to the small sample size or whether it reflects a lack of economic difference between male- and female-owned firms.

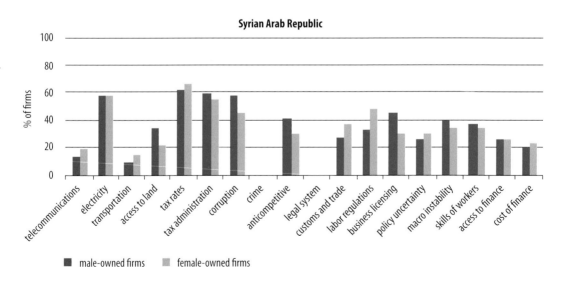

Source: World Bank Enterprise Survey data, 2003–06.

Note: Stars indicate differences that are statistically significant at the 1 percent level or the 5 percent level.
Given the small sample size, it is not possible to determine in countries with a relevant but not statistically significant difference if the result is due to the small sample size or whether it reflects a lack of economic difference between male- and female-owned firms.

FIGURE 3A.1 (continued)

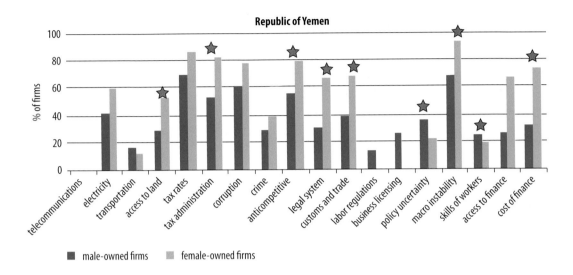

Source: World Bank Enterprise Survey data, 2003–06.

Note: Stars indicate differences that are statistically significant at the 1 percent level or the 5 percent level.
Given the small sample size, it is not possible to determine in countries with a relevant but not statistically significant difference if the result is due to the small sample size or whether it reflects a lack of economic difference between male- and female-owned firms.

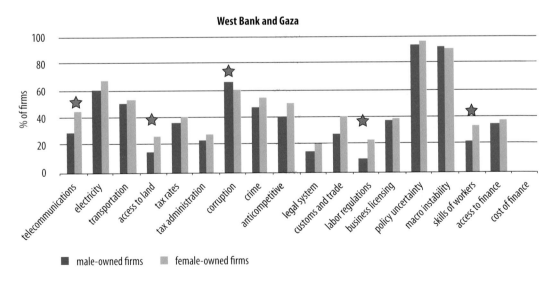

Source: World Bank Enterprise Survey data, 2003–06.

Note: Stars indicate differences that are statistically significant at the 1 percent level or the 5 percent level.
Given the small sample size, it is not possible to determine in countries with a relevant but not statistically significant difference if the result is due to the small sample size or whether it reflects a lack of economic difference between male- and female-owned firms.

TABLE 3A.1

Percentage of Male- and Female-Owned Firms Reporting Investment Climate Constraints as Major or Very Severe Obstacles to Business Operation and Growth, by Gender of Owner and Country

	Egypt, Arab Rep. of		Jordan		Lebanon	
	Male-owned firms	Female-owned firms	Male-owned firms	Female-owned firms	Male-owned firms	Female-owned firms
Telecommunications	7**	1**	21	12	32	25
Electricity	20**	30**	27	22	62	66
Transportation	5	4	14	15	41**	38**
Access to land	20***	29***	34	34	34	44
Tax rates	50	49	54	57	60	70
Tax administration	37	36	38	37	55	67
Corruption	65	60	43	44	60***	82***
Crime	—	—	13	12	20**	30**
Anticompetitive practices	63	60	29	24	50***	62***
Legal system	17	24	17	21	57	58
Customs and trade	24	26	17	18	43	41
Labor regulations	34**	25**	13**	24**	37	44
Business licensing	13	13	45	42	30	39
Policy uncertainty	61	61	52**	61**	49***	69***
Macro instability	72	68	55	62	49	46
Skills of workers	37	34	27	36	38	39
Access to finance	29	23	29	18	38	39
Cost of finance	44	42	—	—	63	70

Source: World Bank Enterprise Surveys, 2003–06.

Note: — = data are not collected in the survey.
** is significant at the 5 percent level.
*** is significant at the 1 percent level.

Notes

1. The existence of a gender dimension in the investment climate is analyzed from a perspective different from that of previous work in the MENA region. Earlier surveys captured the responses of women entrepreneurs, showing that women entrepreneurs are optimistic about their businesses. Feeling successful and empowered, women entrepreneurs believe that, on balance, their gender does not hold them back in society or affect their businesses, though they acknowledge that they face some challenges (CAWTAR and IFC-GEM 2007).

2. The survey asked responders to rate the severity of issues as constraints to operating in the formal business sector. Survey responders chose from a four-point scale: 0 was no obstacle, 1 was a minor obstacle, 2 was a moderate obstacle, 3 was a major obstacle, and 4 was a very severe obstacle. From these answers, a categorical variable for each constraint was built (0 if the answer is no obstacle, 1 if the answer is either a minor or moderate obstacle, and 2 if the answer is either a major or very severe obstacle).

3. Differences in male- and female-owned firms' perceptions are tested by a binary chi-squared test, which verifies the hypothesis that the rows and the

Morocco		Saudi Arabia		Syrian Arab Rep.		Rep. of Yemen		West Bank and Gaza	
Male-owned firms	Female-owned firms	Male-owned firms	Female-owned firms	Male-owned firms	Female-owned firms	Male-owned firms	Female-owned firms	Male-owned firms	Female-owned firms
2	0	3	3	14	19	na	na	31**	46**
10	2	12	9	58	59	42	61	62	69
6	9	13**	23**	10	15	16	13	52	54
44	39	44	54	35	22	30**	53**	16**	28**
63	64	14	9	62	67	71	87	38	41
34	30	8	9	60	56	53***	84***	24	29
17	18	14	11	58	46	62	79	68***	62***
8	8	—	—	—	—	29	40	49	56
38	38	24	17	41	31	56**	81**	42	52
30	23	21	32	—	—	31***	68***	16	22
14	15	16	15	27	37	40**	69**	29	42
16	18	55**	47**	33	48	14	—	10***	24***
18	17	48	56	46	30	26	—	39	41
—	—	27	35	26	31	36**	23**	95	97
24	24	27	27	40	35	69**	94**	94	92
20**	33**	47	55	37	35	25***	19***	23**	35**
79	74	44	45	26	26	26***	68***	36	39
80	74	42	42	21	23	32***	75***	—	—

columns in a two-way table are independent. The hypothesis tested is that there is no relationship between the gender of the enterprises' owners and their perceptions of barriers. Whenever possible, the robustness of the results is checked by multivariate analysis controlling for female ownership, size (number of workers employed), location (whether the enterprise is located in the capital city), sector of activity (textile, agro-food, other manufacturing, or services), experience in the market (logarithm of years of activity), and managerial skills (logarithm of years of education for the top manager).

4. Slightly different findings about perceptions of constraints to business development were stressed in the Investment Climate Assessment for Egypt in 2005. Based on the Enterprise Survey carried out in 2004, the 2005 assessment found no significant differences between male- and female-owned firms. The data in this report are for 2006.

5. No objective indicators are available for access to land.

Is It More Difficult to Start Female-Owned Firms?

The business environment in the Middle East and North Africa (MENA) region may not be as gendered as presumed for this sample of formal firms, with the exception of selected barriers in some countries. However, the interaction of the business environment with other spheres of life might create barriers to women doing business. Outside the business environment, women may still face gender-based barriers that discourage them from starting businesses or that hamper the growth of their businesses.

The report identifies three factors that may explain why there are fewer women entrepreneurs in this region than in others. First, attitudes toward women and work may be less favorable to working women and, by extension, to female entrepreneurship. Second, gender-neutral barriers for opening and closing a business could have unintended gender-differentiated effects. Third, laws in other areas could affect the implementation of investment and business laws (which are largely gender neutral or gender blind), especially in the face of opaqueness or ambiguities.

Attitudes toward Working Women May Hinder Women's Entrepreneurship

Attitudes about the value of work, working women, and gender equality affect women's economic participation and entrepreneurship everywhere, but especially in MENA, where optimism and attitudes toward working women are less positive than in other regions. Combined with the perception of weaker governance and corruption, these attitudes are likely to hinder female entrepreneurship, affecting women's work choices more than men's.

The analysis in this section is based on four indexes—optimism, value of work, attitudes toward working women, and work preference—

disaggregated by gender, which measure demographic characteristics, perceptions of gender, and attitudes toward work and entrepreneurial qualities. Country-level data come from the International Labour Organization (2003), and individual-level data come from the World Values Survey (WVS).[1] These indexes condense responses to many questions into a single number, comparable across countries.[2] Multivariate analysis controlling for demographic and country characteristics is used to determine how much these indexes explain employment outcomes (see appendix A to this report for details).

On the index for optimism—defined as imagination, independence, and the ability to take initiative—differences between men and women in the region are minor and statistically insignificant (table 4.1). People of both sexes score significantly lower than people in other regions, except South Asia (SA). Such low optimism seems likely to affect entrepreneurship, for both men and women.

The index for the perceived value of work, which captures how much importance people attach to work compared with leisure and unemployment, has important consequences for women's employment and entrepreneurship outcomes. The reported value of work is more strongly correlated with employment for women than for men, even though the differences between men and women in the region on the value of work are statistically insignificant.[3]

TABLE 4.1

Country-Level and Regional Characteristics

Country or region	Educated[a] (percentage)		Age (population average)		Optimism (index)		Value of work (index)	
	Women	Men	Women	Men	Women	Men	Women	Men
Algeria	86	88	34	35	3.11	2.99	2.78	2.69
Egypt, Arab Rep. of	59	70	34	37	2.67	2.74	3.64	3.83
Iran, Islamic Rep. of	84	89	31	33	3.06	3.41	3.29	2.94
Jordan	82	85	34	34	3.28	3.13	4.10	4.30
Morocco	38	38	35	34	3.12	3.03	4.21	4.21
Saudi Arabia	95	99	32	33	3.41	3.53	2.86	2.80
Regional comparisons								
Middle East and North Africa	74	78	33	34	3.11	3.14	3.48	3.46
East Asia and Pacific	88	94	38	39	3.44	3.34	5.29	5.23
Europe and Central Asia	94	94	39	39	3.05	2.81	5.90	5.80
Latin America and the Caribbean	84	88	36	36	3.83	3.62	4.69	4.69
South Asia	58	72	34	37	2.27	2.90	—	—

Source: World Values Survey 1999–2004; World Development Indicators 2005 (for data on education in Western Europe and Europe and Central Asia).

Note: — = data not available. Aggregate figures for regions exclude Africa because the three African countries in the sample of 64 are not representative of the region as a whole.

a. "Educated" refers to people with at least primary education.

Men and women in the Middle East report a low value of work—considerably lower than in Latin America, East Asia, or Europe and Central Asia (ECA). This does not mean that individuals in the Middle East are less motivated to work or work less.[4] Indeed, the region scores low for the value of leisure. A lower index for the value of work indicates a lower relative preference for paid employment compared with other objectives—perhaps more important—such as spending time with family or on religious practices or charity (figure 4.1). It might be the case that in countries with lower unemployment than MENA, a region that has had high unemployment, the social stigma of not working is higher, so all individuals, regardless of employment status, report a higher value of work. Until the recent economic boom, well-paying jobs in the private sector have also been scarce in many Middle Eastern and North African countries. In a number of countries, men preferred to remain unemployed rather than lose their place in line for a well-paid job in the public sector, leading to persistently high unemployment (World Bank 2007d). And for women, working has long carried a stigma—only slowly dissipating—because it implied that the male head of the household could not provide for the family. As breadwinners, men were also long considered more deserving of scarce jobs—though this attitude is slowly changing—discouraging women from seeking employment.

The relationship between the value of work and male employment is insignificant, suggesting that men in most countries work regardless of their personal attitudes. The value of work has greater explanatory pow-

FIGURE 4.1

Some Nonwork Activities Are Valued in the Middle East

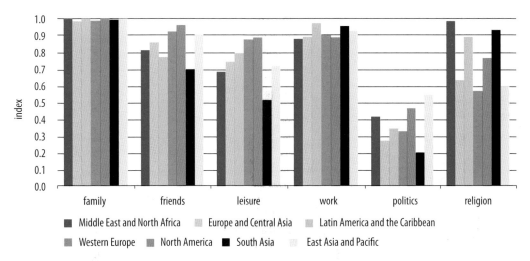

Source: World Values Survey 1999–2004.

er for female employment than male employment, perhaps suggesting that in countries with fewer job opportunities, only individuals with the greatest need or personal motivation to find paid employment are likely to work. This result holds for both middle- and high-income countries and for MENA in particular—important for women's entrepreneurship in the Middle East, given the lower value of work there.

Attitudes Toward Work Affect Women's Employment Choices More than Men's

That attitudes affect women's employment choices more than men's can be demonstrated by examining an index of work preference that combines the optimism and value of work indexes with demographic data for 62 countries across regions.[5] The relationship between women's work preference and female labor force participation is significant and positive (figure 4.2).[6] The relationship between work preference and female entrepreneurship is also positive, though not statistically significant because of the sample size.[7]

Attitudes toward working women are also correlated with women's employment and entrepreneurship across regions,[8] measured by an index of responses to two questions addressing society's attitudes toward women as mothers and workers.

Attitudes toward working women—both women's and men's—are less positive in MENA than in other regions, except SA (table 4.2). Women's

FIGURE 4.2

The Work Preference Index Is Positively Correlated with Female Labor Force Participation and Female Entrepreneurship

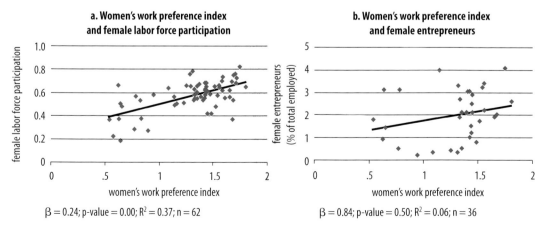

a. Women's work preference index and female labor force participation

$\beta = 0.24$; p-value $= 0.00$; $R^2 = 0.37$; n $= 62$

b. Women's work preference index and female entrepreneurs

$\beta = 0.84$; p-value $= 0.50$; $R^2 = 0.06$; n $= 36$

Sources: World Values Survey 1999–2004; World Development Indicators 2003.

attitudes toward working women are more positive than men's, across both regions and countries (except for the Islamic Republic of Iran and Saudi Arabia). The difference between the male and female indexes, however, is far wider in the Middle East than elsewhere and is statistically significant. Men's less favorable attitude toward working women may affect women's labor force participation, especially because women have to obtain the permission of their husbands to work in most Middle Eastern countries. More negative attitudes toward working women might also result in less attention from state institutions and government workers processing business and license applications for female entrepreneurs.

There is a positive relationship between attitudes toward working women and female labor force participation: in countries with more positive overall attitudes toward working women, female labor force participation is higher (figure 4.3). This relationship is significant, even controlling for such factors as education and gross domestic product (GDP) per capita.

The relationship is stronger for women's attitudes toward working women than for men's. For example, Saudi Arabia has the lowest female labor force participation—even lower than that of the Arab Republic of Egypt and Jordan, two countries with more negative male perceptions of working women. Saudi Arabian women's attitudes toward working women, however, are the lowest in the region. The reverse is true in Jordan, where men's attitudes are very negative, women's attitudes less so, and women's labor force participation slightly higher, though still fairly low.

TABLE 4.2

Attitudes toward Working Women Are Less Positive in the Middle East Than in Most Other Developing Regions

Country	Index of attitudes toward working women		Average score (men and women)
	Women	Men	
Algeria	4.31	3.86	4.08
Egypt, Arab Rep. of	3.89	3.47	3.68
Iran, Islamic Rep. of	4.22	4.25	4.23
Jordan	4.08	3.52	3.78
Morocco	4.26	3.81	4.06
Saudi Arabia	3.88	4.06	3.97
Regional comparisons			
Middle East and North Africa	4.11	3.83	3.97
East Asia and Pacific	4.22	4.19	4.22
Europe and Central Asia	4.34	4.27	4.31
Latin America and the Caribbean	4.39	4.32	4.37
South Asia	3.86	3.80	3.83

Source: World Values Survey, 1999–2004.

FIGURE 4.3

Attitudes Toward Working Women Are Correlated with Female Labor Force Participation—and Entrepreneurship

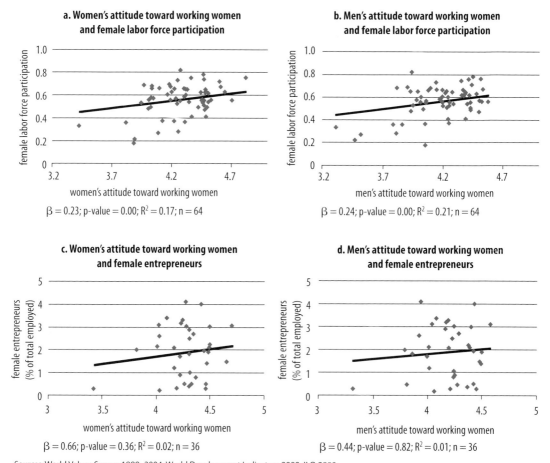

Sources: World Values Survey 1999–2004; World Development Indicators 2003; ILO 2003.

The relationship between attitudes toward working women and female entrepreneurship—examined across 36 countries—is also positive. And though the relationship is not statistically significant because of the sample size, the correlation with women's entrepreneurship is again stronger for women's attitudes than men's.

Weaker Governance Limits Women's Work Choices

Women's work choices also appear to be more influenced by the overall governance environment and the investment climate, a particular concern because of the many barriers to doing business in the Middle East. Work preference and labor force participation are positively correlated— for both men and women—with indexes for rule of law and control of

corruption (figure 4.4). For both men and women, work preference's relationship with the perception of corruption is significant, with the correlation higher for women. This might indicate either that in societies where women are active participants in the economy, governance is better, or that societies with greater inclusiveness and access to law and order are more open to women working—creating more opportunities for women to compete for jobs as a result of a greater emphasis on qualifications and meritocracy. There are many reasons why women might be affected disproportionately by corruption and poor governance. Those in government hiring positions might use their positions as a source of patronage or jobs might be given to those with connections, known as *wasta* in the Middle East.

Multivariate analysis, used to determine the explanatory power of the indexes for employment, shows that attitudes and preferences, such as the value of work (and the shame of unemployment) and opinions of women working, indeed affect female labor force participation rates, even after controlling for age, education, marital status, and household income. Although these preferences also affect male employment, they often do not do so to the same degree or even in the same direction. Overall, the analysis suggests that country-level perceptions and attitudes, both men's and women's, about the value of work and working women influence (or are influenced by) female labor force participation and entrepreneurship.

Most important, the correlation of attitudes with employment is stronger for the Middle East than for the larger groups of high- and

FIGURE 4.4

Work Preference and Labor Force Participation Are Positively Correlated with Rule of Law and Control of Corruption

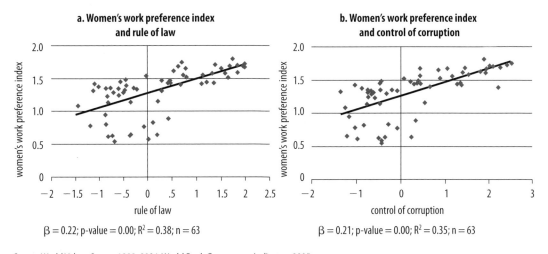

a. Women's work preference index and rule of law

b. Women's work preference index and control of corruption

$\beta = 0.22$; p-value $= 0.00$; $R^2 = 0.38$; n $= 63$

$\beta = 0.21$; p-value $= 0.00$; $R^2 = 0.35$; n $= 63$

Source: World Values Survey 1999–2004; World Bank Governance Indicators 2005.

middle-income countries, suggesting that female participation in the labor market in the Middle East is more affected by attitudes. These correlations do not prove causality, an important area for future research, but even so they should inform policy discussions. Perceptions about women's role in the economy are strong in the Middle East. To change the composition of the labor force—and encourage greater female entrepreneurship—these social attitudes should be addressed through targeted communication programs.

Gender-Neutral Obstacles to Doing Business Can Hit Female Entrepreneurs Harder

Available studies on the region suggest that its informal economies are large, diverse, and growing. Women are a large part of the informal economy, through self-employment or informal entrepreneurship. Women's self-employment—often a precursor to entrepreneurship worldwide, particularly among women—is about as widespread in the Middle East as in other regions (table 4.3). But formal female-owned microenterprises are far less so.[9] Why?

Part of the answer is the difficult transition from the informal sector to the formal sector—complex procedures, costly registration fees, and high minimum capital requirements. Even if gender neutral, such obsta-

TABLE 4.3

Self-Employment Is about as Common in the Middle East as in Other Regions

Country	Self-employed workers (percentage of total employment)	
	Female	Male
Algeria	2	6
Egypt, Arab Rep. of	6	20
Iran, Islamic Rep. of	1	4
Jordan	—	—
Morocco	1	3
Saudi Arabia	—	—
Regional comparisons		
Middle East and North Africa	2.4	8.5
East Asia and Pacific	2.4	6.3
Europe and Central Asia	1.9	5.7
Latin America and the Caribbean	—	—
South Asia	1.9	4.4

Source: ILO 2003.

Note: — = data not available. Self-employed refers to Key Indicators of Labor Markets data, which define self-employment as the sum of employers, own account workers, and producers' cooperatives.

cles can hit women harder, particularly when combined with challenging social norms and attitudes. Gender differences in risk-taking help explain why this might be so.

The cost of opening a business is higher in the Middle East than in any other region (figure 4.5; World Bank 2007a). The costs of registration, minimum paid-in capital requirements, and other fees are more than 800 percent of the region's average per capita income. Starting a business costs 5,000 percent of per capita income in the Syrian Arab Republic, making it one of the most expensive places in the world for entrepreneurship (World Bank 2005a).

These costs may have gendered effects. Low capital requirements are more likely to entice women: in regions with lower start-up costs, the proportion of micro firms owned by women is higher. In the Middle East and Sub-Saharan Africa (SSA), the two regions with the highest required start-up capital, female-owned micro firms are less common than male-owned micro firms. But in Latin America and the Caribbean (LAC), ECA, and SA, female-owned micro firms are more common than male-owned micro firms. High capital requirements are a particular problem for women because they typically inherit less money than men. They may also inherit less land or real estate, which are important as collateral.[10]

Cumbersome and lengthy procedures for starting a business can also have gender-differentiated effects. Again, the number of procedures required is higher in the Middle East than elsewhere (except SSA), even if the time required is lower, potentially creating more opportunities for

FIGURE 4.5

The Costs of Opening and Closing a Business Are High in the Middle East, as Are the Number of Procedures Required

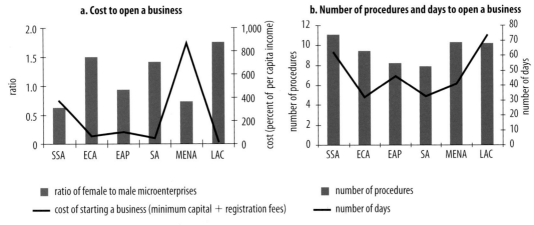

Sources: World Bank Doing Business database and Investment Climate Assessment data.

corruption and bureaucratic entanglements. Women might be more susceptible to requests for bribes in more corrupt countries because they might be seen as less powerful, and women might find navigating red tape and government bureaucracies more difficult in countries with weaker governance. More procedures can be associated with higher corruption in most countries, because each procedure is an opportunity for functionaries to extract a bribe or delay the process when payment is not made.

Cumbersome and costly procedures for closing a business further weaken the environment for entrepreneurship in the Middle East. Sound policies governing bankruptcy and insolvency allow less productive firms to leave the market easily, reallocating their human capital and financial resources to more efficient use. Cumbersome procedures, however, make banks reluctant to extend start-up loans, fearing the costs of default if the business suffers. Investors will also be less likely to take risks if they know that recovering their capital will be difficult and costly if the business fails.

Closing a business is more difficult in the Middle East than in many other regions, and the rate of recovery is lower (figure 4.6; World Bank 2004a). On average it takes three years to close a business, and the recovery rate on initial capital is 30 percent or less.

Again, this obstacle might be a greater barrier to women, for many of the same reasons as starting a business. A woman's working lifecycle is far

FIGURE 4.6

Closing a Business in the Middle East Is Cumbersome and Costly

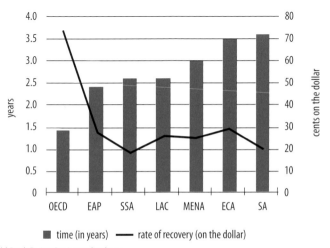

Source: World Bank Doing Business database.

less predictable than a man's because of her role in the family. This phe-
nomenon could have more relevance in MENA. Take female labor force
participation as an example. In other regions, women enter the labor
force and remain there (figure 4.7). In the Middle East, however, women's
labor force participation drops sharply during ages 25–29—typical years
where family social pressures might push women out of the labor market.
Similar pressures may affect young women entrepreneurs as well. The
need for greater flexibility to scale down or abandon business aspirations
to meet family needs is an often-stated fact of life for women entrepre-
neurs, many of whom choose to stay in the informal sector, where they
have greater flexibility to scale up or down depending on their personal
circumstances.

The World Bank's 2008 Doing Business report notes that countries
with more cumbersome business environments have smaller shares of
women entrepreneurs and vice versa (figure 4.8). According to the report,
simplifying business processes is likely to create more first-time female
business owners at a rate 33 percent faster than for their male
counterparts.

Business and Economic Laws Are Not a Problem for Female Entrepreneurship—Other Laws Are

The legal environment may hinder female entrepreneurship, but it does
so in subtle ways. Discrimination in the legal and regulatory framework
in MENA is both explicit and implicit. Understanding the business envi-

FIGURE 4.7

Women in the Middle East Begin to Leave the Labor Force between Ages 25 and 29

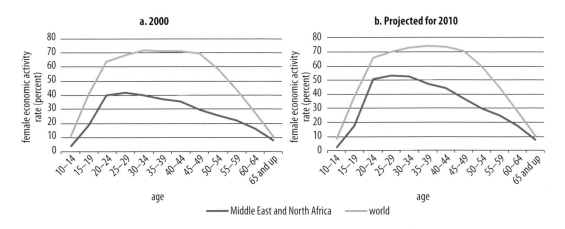

FIGURE 4.8

Business Regulations and Female Entrepreneurship

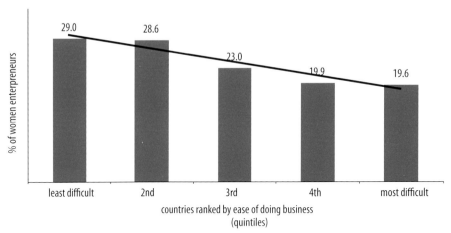

Source: World Bank Doing Business 2008.

Note: Relationships are significant at the 1 percent level and remain significant controlling for income per capita.

ronment for female entrepreneurs requires examining how laws are applied in the context of norms that ascribe particular roles to women.

Elements of the legal framework are unequivocal about women's rights, with nondiscriminatory business laws, constitutional statements of women's equal citizenship, and support from the shari`a (the basis for Islamic law that forms part of the legal framework) for women's economic rights. But problems arise in gray areas. Gendered laws outside the business sector and other elements of the legal framework can lead to gendered implementation of laws, which can disadvantage women, women entrepreneurs, and female-owned firms. These obstacles make starting formal businesses more difficult for women, directly by creating additional barriers and indirectly by raising the costs and uncertainty of resolving conflicts and enforcing contracts. As discussed, such costs and uncertainty can affect the initial decision to pursue entrepreneurship in the formal sector.

The findings about the legal environment are based on two sources. The first is a review of the business and investment laws of several Middle Eastern countries (Algeria, Djibouti, Egypt, the Islamic Republic of Iran, Jordan, Lebanon, Morocco, Tunisia, and the Republic of Yemen) to assess whether the wording of laws discriminates against women and, if so, to what extent. The review included constitutions, civil codes, labor codes, and investment and other business-related country-specific laws (see appendix B to this report for a complete list of the laws reviewed). The second source is a survey sent to lawyers from all countries in the region to identify any legal differences, gray areas, or gaps in the legal sys-

tem that could lead to different interpretations of the laws for men and women. The laws fall in three categories:

1. *Gender blind.* The language of these laws is completely neutral. For example, there is reference only to "the applicant."

2. *Gender inclusive.* The language includes references to men and women, and terms are defined to include women. For example, Egypt's recent income tax law uses a combination of "his and her" throughout the text.

3. *Gender differentiated.* The language of the law refers to explicit differences and differential treatment by sex or gender, clearly describing the rights that apply to men or women and those that do not (for more on the difference between sex and gender, see box 4.1).

Middle Eastern constitutions state unequivocally that women and men are equal citizens with equal rights and responsibilities, such as the right to vote or work. And almost all business and investment laws of most, if not all, Middle Eastern and North African countries are gender blind, without overt discrimination against women. This is good news because mobilizing support for changing laws is far more complicated than improving implementation, itself a formidable challenge. No business or investment law specifically restricts women or applies differential treatment in owning a business, managing a business, applying for loans and accessing credit, or in trade, taxation, or bankruptcy.

The shari`a is an important resource for boosting women's economic rights, legal independence in business matters, and entrepreneurship. The shari`a is unequivocal about women's right to inherit and to control property and income from their wealth, without any reference to, or interference from, male kin or guardians. Rights to control assets, to own property, and to enter into any legal business arrangements are important building blocks for entrepreneurship. In these, women's rights are uncontested and the same as those of men.

But these clear lines blur in other areas, where at times legislation was adapted from Western legal models. Often gender differentiated, labor codes typically include separate discussion of women. These provisions set the requirements for an acceptable workplace (for women only), establish industries where women are not allowed to work, and explain the types of leave women can take. Most striking are provisions that disallow work during certain hours and that require the husband's permission to work. The labor codes of Egypt, the Islamic Republic of Iran, Kuwait, Lebanon, and the Republic of Yemen bar women from working during certain evening and night hours. These labor laws, however, are intended to protect women employees and may not be directed at female entre-

Sex, Gender, and Discrimination

An important theme throughout the report is the difference between sex and gender. Gender, unlike sex, is not biologically determined and changes and evolves over a lifetime. Gender is a social construction that organizes individuals on the basis of external differences. Nowhere are gender roles and divisions more ingrained than in a country's legal institutions, where gender can be far more important than such factors as race, age, or ethnic origin. Gendered categories or gendered social classifications presume that a person must follow a certain pattern, determining the relationship between the individual and the state, market, family, and community (Tilly and Scott 1978).

Gender-neutral policy language may not result in gender-egalitarian outcomes when implemented in a gendered environment, influenced by gender imbalances and biases. The neutral language of many laws works in concert with social mores, traditional customs, constitutional interpretation, and cultural expectations in ways that may stymie the economic advancement of women. So, discrimination in the legal and regulatory framework of Middle Eastern countries may be both explicit and implicit, making it much more difficult to identify implicit gender bias. Doing so depends in large part on value judgments about desirable social and economic behavior, which are likely to vary considerably across societies and eras (Stotsky 1997b).

Source: Authors' compilation.

preneurs. Some evidence, however, suggests that the labor codes are sometimes applied to women employers as well, affecting the sectors where they can invest or the hours when they can operate their businesses.

While little or no specific discrimination affects female entrepreneurs, contradictory laws and regulations make women's rights opaque in several areas, leaving implementation to the discretion of judges. Two factors are key, according to the survey of Middle Eastern lawyers undertaken for this report. First, legislation outside the usual set of laws governing the investment climate can undermine the rights of female entrepreneurs. Second, the range of interpretations within a single country is considerable, leaving room for arbitrary rulings.

Unequivocal language about equal citizenship for men and women does not mean that Middle Eastern constitutions are gender blind; rather, they are a key area of gender-based treatment. Gender-based differences appear in the treatment of the family and women's family role and in references to the shari`a as a source of law.

First, all Middle Eastern constitutions identify the family, rather than the individual, as the central unit of society. Preserving the family is an important duty of the state, which guarantees and protects the family through its authority and institutions. Without exception, constitutions based on the family (inside and outside the region) consider the man as the main breadwinner and the head of the family and the woman as a wife and mother—relying on traditional gender roles and sexual divisions of labor. These constitutions treat women's economic role as unnecessary or secondary (Pyle 1990).

This approach often translates into overprotective laws or gendered legal interpretations in cases of ambiguities. Obedience laws, for example, which are outside business legislation, obligate women to obey their husbands. In most cases, a woman's disobedience can be grounds for divorce and loss of child custody. A host of other laws aim to ensure the husband's authority over the family and his wife, requiring women to obtain the permission of husbands to work and travel, for example. Two effects from such laws and interpretations are critical, according to lawyers surveyed for this report.

The requirement that women get the permission of husbands to obtain a passport or travel is a significant impediment to doing business. Obtaining a loan can be harder as well. Although banking laws do not discriminate against women borrowers, banks across many countries ask for the husband as a cosigner, even if he lacks the financial resources or is not involved in the venture. The intent is to ensure that the woman's actions do not interfere with the wishes of the family or her husband.

Second, nearly all constitutions incorporate references to the principles of the shari`a. Despite the shari`a's strong support for women's economic rights, it also makes an important distinction between equality and equity—a subtle difference that affects the treatment of men and women. Equality normally refers to absolute equal claims, regardless of any other considerations. Equity is based on the notion of different roles and needs affecting rights. Men and women play different roles in the family and society, with different financial responsibilities. Men are responsible for providing for the family. Women are not. This means that men should be given resources in accordance with their responsibilities. According to the shari`a, for example, men inherit twice as much as women because they bear the financial burden for the entire family.

As a result, the implementation of business and economic laws can be influenced by interpretations of gender roles, especially by normally conservative judges. There are reported cases of men being awarded judgments in lawsuits—even in such cases as collecting receivables—because of the judge's interpretation that family responsibilities make the man more deserving of the settlement. Such rulings can affect women's access

to justice, either by lengthening the process or by reducing their chances of winning. A successful, Harvard-educated businesswoman from the United Arab Emirates notes, for example, that she tries to avoid litigation because "a woman without support could not take it up to the desired level for getting justice."

Notes

1. The complete World Values Survey (WVS) database is available at www .worldvaluessurvey.org.
2. For examples of studies that use the World Values Survey to construct composite indexes, see Tonoyan (2003) and Lee (2006).
3. A striking feature of the optimism and value of work indexes is that they vary substantially by country and region but little across genders within countries, suggesting that attitudes and perceptions are driven primarily by country-level culture, behavior, and norms.
4. Leisure, friends, and politics are rated low as well.
5. The work preference index for male and female respondents is calculated by averaging indexes for age and education (demographics) as well as optimism and value of work (perceptions). Gender-specific data are used in constructing the women's and men's composite indexes for work preference. The index takes on values from 0 to 2. On average, the work preference index is higher for women than for men—with the exception of the MENA region. In particular, women in Egypt, the Islamic Republic of Iran, Jordan, and Saudi Arabia have lower indexes than men in their respective countries.
6. Results are also robust to the World Development Indicator (WDI) unemployment rates and WVS unemployment rates. There is a slightly negative relationship between male labor force participation and male work preference, because on average lower-income countries have a slightly higher percentage of employed men. The relationship between male work preference and labor force participation is not statistically significant, however, suggesting that men may work irrespective of their value of work.
7. The analysis of entrepreneurship includes only 36 countries, with only Algeria, the Islamic Republic of Iran, and Jordan from the Middle East, because Egypt's high self-employment rates (more than 20 percent) make it an outlier.
8. Attitudes toward working women are measured by an index constructed using the weighted average of attitudes toward two statements: that a working mother can have as warm a relationship with her children as a woman who does not work, and that a husband and wife should both contribute to the household income. A high value on the index indicates a more positive attitude toward working women. This index is constructed by gender and for the whole population, with the hypothesis that both female and male perceptions of working women should affect women's workforce participation. So women may have fewer job opportunities in countries where men—and women—disparage working women. An important caveat is that more negative perceptions of working women might be expected in countries where there are fewer em-

ployed women because employees are less likely to have female colleagues or managers.

9. Microenterprises are those with fewer than 10 employees.

10. Despite the right to inherit land and real estate, women more frequently inherit liquid assets or furniture—which cannot be collateralized—reflected in the far lower share of land owned by women.

How to Boost Female Entrepreneurship

Although well-established in the Middle East, women's entrepreneurship has not reached its full potential. The shortage of small and micro male- and female-owned firms in the region suggests high barriers to entry into the formal sector for all. While the investment climate in the Middle East and North Africa (MENA) is similar for men and women, female-owned firms in some countries perceive some constraints as more binding than do male-owned firms. Women face additional hurdles—gender related and costly—outside the investment environment. These barriers restrain the ability of firms to grow to their potential, inflicting costs that will ultimately be paid by all. More important, they restrain the number of female-owned firms that can enter the formal sector.

Now is the time to spur women's entrepreneurship. Having invested significantly in education over the last decades, the Middle East is closing the gap on gender disparities, and in 11 of 18 Middle Eastern countries, women outnumber men at universities. Labor force participation, while low compared with that in other regions, is growing fast. But the surge in participation rates of workers ages 25–30 over the five years since 2003, especially among educated women, has left women's unemployment two to four times men's, when overall unemployment is declining.

As a result, many women choose self-employment out of necessity, perhaps starting their businesses in the informal sector. But these self-employed women are very different from those of earlier generations—and from the commonly held view of micro-entrepreneurs. Their activities are far more knowledge based and far more plugged into global markets through information and communication technologies.

With this clear potential, women's entrepreneurship has become a popular cause. Governments, the private sector, donors, and nongovernmental organizations are promoting women's economic empowerment in the Middle East, with women's entrepreneurship a key tool. So far, much has been spent on advocating women's access to finance (with emphasis

on microfinance), building capacity for entrepreneurship, and organizing and strengthening women's business associations.

These activities are necessary and useful. But the analysis in this report suggests that it would be far more helpful to reduce the barriers for all investors to open, operate, and close firms and to address social norms and gender-based differential treatment under the law.

Reduce Barriers to All Firms

Reforming the business climate to reduce barriers to opening and closing firms would benefit all. Cutting the cost and complexity of opening a formal business allows entrepreneurs to take advantage of market opportunities, which, because of globalization, are evolving faster than ever. By contributing new ideas, technologies, and production methods, these businesses can boost productivity growth across the economy, even spurring existing firms to raise their productivity. Reducing barriers to exit ensures that capital and resources can easily flow to more productive uses.

Such reforms would help women in particular. Regions with lower start-up capital requirements and lower exit barriers have higher shares of female entrepreneurs in the formal sector. Because of their dual roles, women everywhere are caught between the demands of work and family. But for a variety of social and legal reasons, women in the Middle East are more constrained than those in other regions by social norms related to work-family issues, making their time horizons more uncertain, which could create greater risk of loss. Investment decisions are forward looking, allocating resources today in the hope of rewards later. Investment climate barriers to opening and closing a business can discourage women more if investments are more costly and time consuming to reverse.

Address Gendered Social Norms and Differential Treatment under the Law

To benefit from economic opportunities and contribute to national growth, women in the Middle East need a level playing field. Educating women has not been enough to change social norms sufficiently, so much remains to be done. Women's opportunities for work are far fewer than those of men, evident in the high unemployment among the relatively low share of women in the labor market—and even more in the concentration of educated women among those unemployed.

Leveling the playing field requires building an environment for these skilled women to create their own opportunities. This means addressing

social norms about working women and promoting an environment where women can balance work and family. Progress on both fronts is an urgent need. The degree of job segregation remains high: most jobs are still in male-dominated sectors that may be seen as inappropriate for women. And the belief that men, as the traditional breadwinners, are more deserving of jobs is still widespread.

It also means addressing gender-based differential treatment under the law. Differential treatment stems from three factors. The first is the dual objectives of the state—to facilitate employment and economic growth but also (at times) to maintain traditional gender roles. This is most evident in policies that define women as legal minors, requiring that their interactions with the state be mediated through a male relative. More and more countries are eliminating such requirements, however, as governments ensure that the interpretation of laws intended to protect the family is not driven solely by traditional perceptions of gender and that these interpretations allow individuals to contribute to family welfare in new ways. Again, the need for reform is great.

The second factor is gendered laws outside business and commerce, because even if business and commercial laws are meant to be gender neutral, other laws can affect implementation in potentially gendered ways. Policy makers need to take a deep look at these contradictions and evaluate whether economic goals are undermined by laws and regulations based on traditional gender roles. If these do interfere with policies for economic growth and inclusiveness, decrees or administrative circulars can instruct state personnel on how to interpret laws consistent with economic policies.[1]

Today, a woman may face fewer challenges in finding foreign buyers for her firm's output, but she cannot board the plane to close the deal if her husband has not given her written permission to obtain a passport and travel. Or she may succeed in attracting the leading foreign investors in her sector to partner in her venture, but she may still have to bring her father or husband to cosign her loan, even though banking laws do not require it.

The third factor driving differential treatment is legal opaqueness, which can create additional risks and potentially hinder women entrepreneurs' access to justice, conflict resolution, and contract enforcement. Though hard data on women's access to justice are unavailable, qualitative surveys and anecdotal evidence reported in the media and by women's advocacy groups suggest that judiciaries in the Middle East remain conservative, perhaps becoming even more so recently. In cases of ambiguities, their interpretations are likely to be influenced by traditional views of gender roles.

Next Steps

This report is one of many efforts to analyze the potential of women entrepreneurs and female-owned firms in the Middle East. It should be followed by much more concerted data collection. These efforts should also look beyond the formal sector by examining women's self-employment and home-based entrepreneurship.

Note

1. Administrative circulars are normally outside the legislative process, where changes take time and can be politically charged, and in the purview of the executive branches of the government and specific ministries.

Perceptions and Female Employment: Methodology and Empirical Results

This analysis studies the relationship between people's perceptions and female employment and self-employment using a large social science dataset. We compare the Middle East and North Africa (MENA) region with other regions of the world and find that attitudes toward the value of work and gender equality are related to employment outcomes. This appendix illustrates that social norms and traditions may have a bearing on women's economic participation and entrepreneurship.

For the purpose of this study, we use the World Values Survey (WVS), which has been conducted in four waves in more than 70 countries around the world. The survey includes detailed demographic information on a random sampling of individuals, including age, employment, marital status, and so on, as well as psychological traits and sociological insights. For instance, questions are asked about individuals' perceptions of government efficiency, job satisfaction, working mothers, and the stigma of unemployment. This unique survey allows a large, cross-country comparison of people's perceptions around the world and of the relationship between these perceptions and economic development, legal enforcement, and gender equality. We include the fourth wave of the WVS, 1999–2004, which is the only wave that includes MENA countries: Algeria, the Arab Republic of Egypt, the Islamic Republic of Iran, Iraq, Jordan, Morocco, and Saudi Arabia.[1] We include in our sample a total of 64 countries in 8 regions around the world, including 6 MENA countries.

We create a series of indexes, disaggregated by gender, that measure demographic characteristics, perceptions of gender, and attitudes toward work and entrepreneurial qualities. The main reason for constructing these indexes is to condense an otherwise large amount of data into a single number that can be compared across different countries.[2] Following Berkowitz and others (1999) and Tonoyan (2003), we use factor analysis to construct our indexes.[3]

World Values Survey Data on Individual Characteristics

We begin by using a principal components analysis (PCA) to create an aggregated *Work Preference Index*. We include indexes for age, education, optimism, and value of work, as well as the composite male and female indexes on attitudes toward working women. Our variables are defined as follows:

- *Age*. This is defined as the working-age population, between ages 15 and 64. For the purpose of analysis, we normalize age to create an age index to facilitate comparison across countries.[4]

- *Education*. This is a dummy variable that takes the value 1 [for individuals with at least a primary education and 0 for those with no education]. This variable measures the educational level attained by the working-age population (those ages 15–64).

- *Value of work*. This index captures how people view work in their daily lives. Our hypothesis is that countries that attach more importance to work have a higher female employment rate than do other countries. The index is based on responses to several statements:
 - Work is more important than leisure.
 - Work is a duty toward society.
 - It is humiliating to receive money without having to work for it.
 - To develop talents, you need to have a job.
 - Work should come first, even if it means less spare time.

- *Optimism*. The ability to take initiative, imagination, and independence are characteristics associated with an entrepreneurial spirit.[5] Our index of optimism is based on responses to the following questions:
 - How satisfied are you with your life?
 - What degree of freedom and choice do you have?

- *Attitude toward working women*. We examine how perceptions of working women affect women's workforce participation, because women may have fewer job opportunities in countries where men (and women) disparage working women. We construct this index by gender and for the total population. A high value on the index represents a more positive attitude toward women working. Our index is based on responses to the following statements:
 - A working mother can have as warm a relationship with her children as a woman who does not work.
 - A husband and wife should both contribute to the household income.

We compare these perception measures to a number of country-level statistics, shown in table A1. First, we use official formal labor force participation rates from the *World Development Indicators* (World Bank 2003b). Second, we calculate country-level female and male employment rates from the WVS data, defined as the percentage of surveyed individuals who identify themselves as formally employed or self-employed.[6] Third, we use a measure of formal self-employment rates from the International Labour Organization "Key Indicators of the Labor Market" survey (KILM). KILM data define self-employment as the sum of employers, own-account workers, and producers' cooperatives. For the purpose of our analysis, we focus on the "employers" category, which is most likely to reflect the formal entrepreneurial sector. We include as measures of governance two indicators from Kauffman, Kraay, and Mastruzzi (2007).[7]

Cross-regionally, we find very low official and WVS female labor force participation rates (and high unemployment rates) in MENA compared with those of men and with those in other regions. But self-employment rates in MENA are about average, with significantly more men than women as employers.

TABLE A1

Key Employment Statistics and Governance Measures

Country or region	WDI labor force participation (% of population)		WVS total employment (% of population)		KILM employers (% of total employment)		Governance	
	Female	Male	Female	Male	Female	Male	Rule of law	Control of corruption
Algeria	36	83	50	72	2	6	−0.71	−0.43
Egypt, Arab Rep. of	22	75	17	82	6	20	0.02	−0.42
Iran, Islamic Rep. of	38	76	20	65	1	4	−0.76	−0.47
Jordan	27	79	5	63	—	—	0.43	0.33
Morocco	28	83	51	76	1	3	−0.10	−0.09
Saudi Arabia	18	81	18	78	—	—	0.20	0.23
Regional comparisons								
EAP	61	84	50	75	1.9	5.7	−0.25	−1.04
ECA	61	74	65	82	1.9	4.4	−0.17	−0.16
LAC	51	83	39	75	2.4	6.3	−0.56	−0.23
MENA	28	80	30	87	2.4	8.5	−0.15	−0.14
North America	71	82	65	81	—	—	1.70	1.74
SA	42	87	14	73	—	—	−0.53	−0.83
Western Europe	62	79	62	82	5.0	8.8	1.41	1.60

Sources: World Bank 2003b; ILO 2003; Kauffman, Kraay, and Mastruzzi 2007.

Note: — = data not available.

Multivariate Analysis

In this section we conduct a multivariate analysis to determine the explanatory power of our constructed indexes on employment. We find that attitudes and preferences, such as the value placed on work (and the shame of unemployment) and opinions about women working, affect female labor force participation rates. These preferences also affect male employment, but not to the same degree, or necessarily in the same direction.

We use the WVS data on more than 55,000 individuals. Our dependent variable is a dummy, equal to 1 if the individual is employed and equal to 0 if the individual is involuntarily unemployed (actively searching for a job).[9] We use a logit model to test the following model:

$$\text{Employed} = \alpha + \beta_i [X_i] + \dots + B_j [\text{Index}]_j + \gamma$$

where "X" is individual demographic characteristics, such as wealth, age, education, marital status, and number of children; and "Index" represents our measures of cultural perceptions (*value of work, attitude toward working women,* and *optimism*). In all regressions we include country dummies (to control for all omitted country-level effects). We test our model for all individuals and for the subsamples of women and men. Furthermore, we test all countries, and the subsamples of high-income, middle-income, and MENA countries.

Table A2 shows results for the relationship between labor force participation and our *value of work* and *attitudes toward working women* indexes. *Value of work* has a significantly positive influence on female and total employment. For the complete sample and in high-income countries (not shown), the relationship between the *value of work* and male employment is insignificant. This suggests that men in most countries work regardless of their personal attitudes. It might also be the case that in countries with lower unemployment, the social stigma of not working might be higher, so that all individuals, regardless of employment status, report a higher *value of work*. In comparison, for middle-income countries with higher unemployment rates, individuals that value work more highly are significantly more likely to be employed (not shown). Furthermore, *value of work* has greater explanatory power for female employment than male employment. This might be interpreted to suggest that in countries with fewer job opportunities, individuals with the greatest personal motivation to find paid employment are most likely to work. This result holds true for both middle- and high-income countries.

Similarly, *attitude toward working women* is very significant for both women and men in all countries, across income levels. Of interest, although the *value of work* index is insignificant for men in high-income countries, the *attitude toward working women* is significant. As previously

TABLE A2

Relationship between Employment and Perception Indexes, Complete Sample

Independent/explanatory variables	R1: Value of work		R2: Attitude toward working women	
	Women	Men	Women	Men
Age (natural log)	−0.376	−1.521	−0.383	−1.485
	(0.057)**	(0.073)**	(0.058)**	(0.074)**
University educated	1.232	0.736	1.276	0.787
	(0.051)**	(0.048)**	(0.051)**	(0.048)**
Married/living together	−0.223	0.551	−0.232	0.553
	(0.039)**	(0.056)**	(0.040)**	(0.058)**
Number of children (natural log)	−0.278	−0.02	−0.264	0.004
	(0.031)**	(0.034)	(0.032)**	(0.034)
Low-income households	−0.79	−0.693	−0.764	−0.612
	(0.038)**	(0.043)**	(0.039)**	(0.042)**
Middle-income households	−0.266	−0.016	−0.25	−0.008
	(0.035)**	(0.039)	(0.036)**	(0.039)
Value of work	**0.067**	**−0.008**		
	(0.011)**	**(0.013)**		
Attitude toward working women			**0.107**	**0.047**
			(0.022)**	**(0.022)***
Constant	1.017	5.188	0.368	4.912
	(0.208)**	(0.271)**	−0.223	(0.284)**
Observations	56,554	56,554	55,876	55,876

Source: WVS 1999–2004.

Note: Standard errors are in parentheses. All regressions include country dummies.
* significant at the 5 percent level.
** significant at the 1 percent level.

discussed, the perception and opinion of women in the workforce is very similar across both men and women within countries. This suggests a relationship between overall employment levels and greater inclusion of women in the workforce. We speculate that it might be the case that in countries with high unemployment, women are discouraged from working (to create more employment for men); alternatively, countries that encourage women to contribute to economic productivity might have more job opportunities overall. We find a similar, significantly positive relationship between *optimism* and employment (not shown).

Table A3 examines these same regressions for the subsample of MENA countries. As shown, all perception indexes are significant for female and male employment. In addition, the coefficients—and relationships—are economically larger for women than for men (except for *optimism*, where the effects are larger for men than for women; not shown). Moreover, the effect is stronger for MENA countries than for both high- and middle-income countries. This suggests that in the context of MENA, female behavior in the labor market is governed to a larger extent by preferential attitudes, especially when compared with the rest of the world.

TABLE A3

Relationship between Employment and Perception Indexes in the Middle East and North Africa Region

Independent/explanatory variables	R1: Value of work		R2: Attitude toward working women	
	Women	Men	Women	Men
Age (natural log)	−0.025	−1.084	0.21	−0.954
	(0.051)	(0.067)**	(0.050)**	(0.066)**
University educated	1.208	0.681	1.154	0.667
	(0.047)**	(0.046)**	(0.046)**	(0.046)**
Married/living together	−0.295	0.407	−0.36	0.362
	(0.038)**	(0.053)**	(0.038)**	(0.054)**
Number of children (natural log)	−0.476	−0.223	−0.585	−0.25
	(0.028)**	(0.031)**	(0.028)**	(0.030)**
Low-income households	−0.722	−0.671	−0.766	−0.655
	(0.036)**	(0.040)**	(0.036)**	(0.039)**
Middle-income households	−0.237	−0.026	−0.257	−0.044
	(0.033)**	(0.037)	(0.033)**	−0.037
Value of work	**0.142**	**0.079**		
	(0.007)**	**(0.007)****		
Attitude toward working women			**0.255**	**0.113**
			(0.020)**	**(0.020)****
Constant	0.275	4.327	−1.203	3.607
	(0.193)	(0.254)**	(0.199)**	(0.263)**
Observations	56,554	56,554	55,876	55,876

Source: WVS 1999–2004.

Note: Standard errors are in parentheses. All regressions include country dummies.
 * significant at the 5 percent level.
 ** significant at the 1 percent level.

Future Work

We have not proven causality at this stage of the analysis. We have only spotlighted the simultaneous relationship between perceptions and labor force participation of women. For instance, negative attitudes toward women working might impact female labor force participation or, alternatively, low female labor force participation might lead to negative attitudes about women in the workforce. This is a subject for future study.

Conclusions

Our main conclusion is that country-level perceptions and attitudes of both men and women about the value of work and working women play a role in (or are influenced by) female labor force participation and entrepreneurship.

Within the MENA region, there are strong perceptions about women's role in the economy. To make a sustainable change in the composition of the labor force and encourage greater female entrepreneurship, these cultural attitudes should be included in the policy dialogue.

Notes

1. We exclude Iraq, because of its small sample size, and some additional countries that are missing the key questions for our analysis.
2. For examples of studies that use the WVS to construct composite indexes, see Tonoyan (2003), Flanagan and Lee (2003), Lee (2006).
3. We use Cronbach's alpha and principal components analysis (PCA). Cronbach's alpha measures how well a group of variables reliably measures a single latent variable. When the alpha is high, the variables are scaled based on their one-dimensional inter-item covariance. However, in cases where variables have a multidimensional structure, Cronbach's alpha would provide unreliable results. In this case, we have used PCA, a multivariate technique that reduces data to lower dimensions based on their variance. Following Berkowitz and others (1999), we employ PCA to derive the most common factors among a group of variables using the covariance matrix. We then take a weighted average of the variables to form a new index. We use the eigenvector of the first component as weights because it accounts for the highest variation among the variables used.
4. The Human Development Index (HDI) is composed of three separate indexes: life expectancy, education, and GDP. We use the method defined in the HDI for scaling age, using age 15 and age 64 as minimum and maximum cutoffs, respectively, for employment age. We normalize age on a scale of 0–1 for ease of comparison.
5. For examples in both developed and developing countries, see Demirgüç-Kunt, Klapper, and Panos (2007); Arabsheibani and others (2000); Puri and Robinson (2005); Heaton and Lucas (2000); Moskowitz and Vissing-Jorgensen (2000); Hamilton (2000); Gentry and Hubbard (2001); Parker (2006); Fraser and Greene (2006).
6. An important caveat is that the WVS data may not be a completely representative sample, because many country surveys focus only on urban areas. However, in general, the rankings of female and male employment are consistent with official data.
7. The complete Kauffman, Kraay, and Mastruzzi (2007) database is available at www.worldbank.org/governance.
8. We exclude from the unemployed category housewives, students, and other individuals that are "voluntarily" unemployed.

Business Laws in Middle Eastern and North African Countries

Algeria

Algeria is part of the Francophonie and as such, much of the language of its laws is derived from French sources. The laws are heavily "he" centered and do not, for the most part, include references to women. The preamble to the Constitution of the People's Democratic Republic of Algeria states

> "Having fought and still fighting for freedom and democracy, the Algerian people, by this Constitution, decided to build constitutional institutions based on the participation of any Algerian, **man and woman**, in the management of public affairs; and on the ability to achieve social justice, equality and freedom for all."

Article 29 of Chapter IV, *Rights and Liberties*, states "All citizens are equal before the law. No discrimination shall prevail because of birth, race, sex, opinion or any other personal or social condition or circumstance."

For Algeria, no investment or business-related law was found that overtly and specifically restricts, or demonstrates differential treatment in, the following areas:

- owning a business;
- managing a business;
- applying for loans and accessing credit; or
- trade, taxation, and bankruptcy.

Djibouti

Djibouti is also part of the Francophonie and as such, much of the language of its laws is derived from French sources. The laws are heavily "he" centered and do not, for the most part, include references to women.

There is one exception—the *Codes des Societes Privees et Publiques* defines "Gerand" as a husband or a wife. The existence of such specific language could lead one to argue that the absence of gender-specific language in other areas is indicative of a possible bias against women.

For Djibouti, no investment or business-related law was found that overtly and specifically restricts, or demonstrates differential treatment in, the following areas:

- owning a business;
- managing a business;
- applying for loans and accessing credit; or
- trade, taxation, and bankruptcy.

The Arab Republic of Egypt

The laws of Egypt, much like the other laws examined, refer predominantly to "he" and "his." The Labor Code, with the exception of one reference to he/she in Article 13, does not make any reference to women. Article 35 of the Labor Code specifies that discrimination in wages because of sex, origin, language, religion, or creed shall be prohibited.

Chapter 2 of the Labor Code deals specifically with the "Employment of Woman Worker":

- Article 88 states that "Subject to the provisions of the following articles, all provisions regulating the employment of workers shall apply to woman workers, without discrimination among them, once their work conditions are analogous."
- Article 89 restricts women's employment to the daytime, stating that "The concerned minister shall issue a decree determining the cases, works, and occasions for which women shall not be employed to work during the period between 7 pm and 7 am."
- Article 90 allows the concerned minister to "issue a decree determining the works that are unwholesome and morally harmful to women, as well as the works in which women may not be employed to work."

Income Tax Law No. 91 of 2005 includes women by making reference to "his/her" throughout the text.

However, throughout the company and commercial laws governing the establishment of limited liability companies, all provisions that require the names of the legal adviser of the company (Article 38), or the council of control (Article 46) use "Mr" designations, thus assuming male parties will hold these positions. However, the text does not overtly restrict women from seeking these positions.

No investment or business-related law was found that overtly and specifically restricts, or demonstrates differential treatment in, the following areas:

- owning a business;
- managing a business;
- applying for loans and accessing credit; or
- trade, taxation, and bankruptcy.

The Islamic Republic of Iran

None of the business and investment laws reviewed was discriminatory on its face, although there is no language that explicitly allows women to own and manage companies. The Labor Code does have a separate section on female workers, which restricts women from engaging in any work that is arduous. Women are also not allowed to work in the evenings.

No investment or business-related law was found that overtly and specifically restricts, or demonstrates differential treatment in, the following areas:

- owning a business;
- managing a business;
- applying for loans and accessing credit; or
- trade, taxation, and bankruptcy.

Jordan

Act No. 43 of 1976 of the Jordanian Civil Code states that

a. Female lawyers have the same rights as male lawyers with regard to the representation of their clients before the courts and specialized judicial bodies.
b. Women may be members of the judiciary, except in courts governed by the shari`a (the basis for Islamic law that forms part of the legal framework).
c. All persons have the right to make contracts provided their capacity to do so has not been revoked or restricted by the law.

With respect to equality before the law, Jordan's Constitution does not differentiate on the basis of sex. The Constitution states that "Jordanians shall be equal before the law. There shall be no discrimination between

them as regards to their rights and duties on the grounds of race, language or religion."

The Jordanian Labor Code (Section 69) states that upon consultation with the competent official bodies, the minister shall adopt a decision specifying

- industries and trades where women's work shall be prohibited; and
- hours in which women may not be employed and exceptions thereto.

For Jordan, no investment or business-related law was found that overtly and specifically restricts, or demonstrates differential treatment in, the following areas:

- owning a business;
- managing a business;
- applying for loans and accessing credit; or
- trade, taxation, and bankruptcy.

Lebanon

Many of the Lebanese laws listed on the World Bank's Doing Business Web site are in Arabic. Within the laws available in French, the section entitled "Travail des Femmes" (the work of women) of the Lebanese Labor Code (1946) states that

> Art. 26. Il est interdit de faire travailler les femmes dans les industries mécaniques ou manuelles pendant la nuit, c'est-à-dire entre huit heures du soir et cinq heures du matin du 1er mai au 30 septembre, et entre sept heures du soir et six heures du matin du 1er octobre au 30 avril.

> Art. 27. L'emploi des femmes est interdit dans les industries et les travaux énumérés à l'annexe 1 de la présente loi.

The list includes industries such as mining, automotive, painting, and explosives.

It is important to note Law No. 207 (2000), amending Articles 26, 28, 29, and 52,

> *Article 26 nouveau*
> Il est interdit à l'employeur d'établir une discrimination entre l'homme et la femme qui travaillent en ce qui concerne le genre de travail, le montant du salaire, l'emploi, la promotion, l'avancement, l'aptitude professionnelle et l'habillement.

For Lebanon, no investment or business-related law was found that overtly and specifically restricts, or demonstrates differential treatment in, the following areas:

- owning a business;
- managing a business;
- applying for loans and accessing credit; or
- trade, taxation, and bankruptcy.

Morocco

The text of the laws of Morocco generally do not include references to women. The Constitution of Morocco, 1996, guarantees that "All Moroccan citizens shall be equal before the law" (Article 5, Chapter 1).

For Morocco, no investment or business-related law was found that overtly and specifically restricts, or demonstrates differential treatment in, the following areas:

- owning a business;
- managing a business;
- applying for loans and accessing credit; or
- trade, taxation, and bankruptcy.

Tunisia

The laws of Tunisia do not include any references to women. The Codes of Civil and Commercial Procedure and the Commercial and Company Laws typically refer to "la personne" and "le gerant." The Tunisian Labor Code is also gender blind. The only section that references women is under Special Provisions in Chapter XII: The Employment of Women and Children in Agriculture.

The Constitution of the Republic of Tunisia guarantees "All citizens have the same rights and obligations. All are equal before the law" (Article 6).

For Tunisia, no investment or business-related law was found that overtly and specifically restricts, or demonstrates differential treatment in, the following areas:

- owning a business;
- managing a business;
- applying for loans and accessing credit; or
- trade, taxation, and bankruptcy.

The Republic of Yemen

The text of the laws of the Republic of Yemen do not include any references to women. The Yemeni Labor Code refers to "worker" and includes references to "men and women."

Article 42 – Women shall be equal with men in relation to all conditions of employment.

Article 46 – It shall be forbidden to employ women at night, except during the month of Ramadan and in the jobs which shall be specified by order of the Minister.

Article 68 – Women shall be entitled to wages equal to those of men if they perform the same work under the same conditions and specifications.

Article 87 – A working woman shall be entitled to leave with pay for 40 days if her husband dies.

Republic Decree Act No. 19 of 1999 on Promoting Competition, Monopoly and Preventions of Commercial Deception includes gender-sensitive language by referring to "his/her."

For the Republic of Yemen, no investment or business-related law was found that overtly and specifically restricts, or demonstrates differential treatment in, the following areas:

- owning a business;
- managing a business;
- applying for loans and accessing credit; or
- trade, taxation, and bankruptcy.

Laws Reviewed

Algeria

Banking and Credit Laws
- Loi n° 90-10 du 14 avril 1990 relative à la monnaie et le crédit
- Règlement n° 2002-03 du 14 octobre 2002 relatif au contrôle interne des banques et établissements financiers
- Règlement n° 2004-01 du 4 mars 2004 relatif au capital minimum des banques et établissements financiers exerçant en Algérie

Bankruptcy and Collateral Laws
- Code civil (Titre III)
- Des faillites et règlements judiciaires (Livre III du code de commerce)

Civil Codes
- Code civil

Civil Procedure Codes
- Code de procédure civile

Commercial and Company Laws
- Code de commerce
- Code des investissements
- Code des sociétés (Livre V du code de comerce)
- Décret n° 05-175 du 18 mai 2005 fixant les modalités d'obtention de l'attestation négative relative aux ententes et à la position dominante sur le marché
- Loi n° 04-02 du 23 juin 2004 fixant les règles applicables aux pratiques commerciales
- Loi n° 04-08 du 14 août 2004 relative aux conditions d'exercice des activités commerciales
- Règlement n° 2005-03 du 6 juin 2005 relatif aux investissements étrangers

Constitutions
- Constitution of Algeria
- Constitution of Algeria

Labor Laws
- Décret législatif N° 94-09 du 26/5/94 portant préservation de l'emploi et protection des salaries susceptibles de perdre de façon involontaire leur emploi
- Loi n° 90-11 du 21 avril 1990 relative aux relations de travail

Land and Building Laws

- Code civil (Livre IV)

Tax Laws
– Code de taxe sur la valeur ajoutée
– Code des impôts directs

– Trade Laws
– Code des douanes
– Décret n° 05-222 du 22 juin 2005 fixant les conditions et les modalités de mise en oeuvre du droit antidumping

Djibouti

Banking and Credit Laws
– Arrêté n° 2004-0438/PR/MAEM-RH portant création d'Une unité de Coordination et d'un comité de pilotage Projet de Développement de Micro finance et de la Micro entreprise (PDMM)
– Décret n° 2006-0020/PRE portant création, organisation et objet du Comité de Réflexion sur la Microfinance (CREM)
– Loi n° 92/AN/05/5ème L relative à l'ouverture, à l'activité et au contrôle des établissements de Crédit
– Loi n° 91/AN/05/5ème L relative aux statuts de la Banque Centrale de Djibouti

Civil Procedure Codes
– Loi n° 52/AN/94/3e L portant création d'une Cour d'Appel et d'un Tribunal de Première Instance

Commercial and Company Laws
– Code des Sociétés Privées et Publiques
– Décret n° 86 116/PRE du 30 novembre 1986 relatif aux sociétés commerciales
– Loi n° 103/AN/05/5ème L portant sur les sociétés commerciales de zone franche
– Loi n° 114/AN/96/3e L relatif à la protection du droit d'auteur
– Loi n° 117/AN/05/5ème L portant Code pétrolier
– Loi n° 170/AN/02/4ème L portant statut du notariat
– Loi n° 191/AN/86/1er L du 3 février 1986 sur les sociétés commerciales
– Loi n° 53/AN/04/5ème L portant Code des zones franches
– Loi n° 65/AN/94/3e L portant création du régime de zone franche industrielle
– Loi n° 66-537 du 24 juillet 1966 sur les sociétés commerciales

Constitutions
– Constitution du Djibouti

Labor Laws
- Code du travail

Land and Building Laws
- Loi n° 177/AN/91/2ème L portant organisation de la propriété foncière
- Loi n° 178/AN/91/2ème L fixant les modalités d'application des loi relatives au régime foncier

Tax Laws
- Loi n° 108/AN/00/4èmeL portant Reforme du Code général des Impôts
- Loi n° 102/AN/05/5ème L portant réforme des services de l'État chargés de la fiscalité et des domaines
- Arrêté n°91-0121/PR/FIN fixant les conditions d'applications de l'article 29.43.01 du Code général des impôts
- Loi n° 155/AN/80 portant modification du Code général des impôts "Taxes sur les propriétés non mises en valeur"

Trade Laws
- Loi n° 102/AN/05/5ème L portant réforme des services de l'État chargés de la fiscalité et des domaines
- Arrêté n° 2005-0634/PR/MEFPCP fixant les charges collectées par la douane pour services rendus

Arab Republic of Egypt

Banking and Credit Laws
- Law of the Central Bank, the Banking Sector and Money (in Arabic)
- Law of the Central Bank, the Banking Sector and Money
- Executive Regulations of the Law of the Central Bank, the Banking Sector and Money (in Arabic)
- Executive Regulations of the Law of the Central Bank, the Banking Sector and Money

Bankruptcy and Collateral Laws
- Decree No. 465 of 2005 amending the Executive Regulations of the Mortgage Finance Law
- Prime Minister's Decree No. 465 of 2005 Amending Real Estate Finance Law No. 148 of 2001
- Executive Regulations of Real Estate Finance Law No. 148 of 2001
- Real Estate Finance Law No. 148 of 2001

Commercial and Company Laws
- Special Economic Zones Law No. 83 of 2002

- Shareholding Companies and Limited Liability Companies Law No. 159 of 1981 (in Arabic)
- Law No. 8 of 1997 on Investment Guarantees and Incentives
- Executive Regulations to Shareholding Companies and Limited Liability Companies Law No. 96 of 1982 (in Arabic)
- Establishment of LLC

Constitutions
- Constitution of Egypt
- Constitution of Egypt (in Arabic)

Labor Laws
- Labor Law
- Labor Law (in Arabic)

Land and Building Laws
- Real Estate Finance Law No. 148 of 2001
- Prime Minister's Decree No. 465 of 2005 Amending Real Estate Finance Law No. 148 of 2001
- Executive Regulations of Real Estate Finance Law No. 148 of 2001
- Decree No. 465 of 2005 amending the Executive Regulations of the Mortgage Finance Law

Securities Laws
- Decree No. 135 of 1993 on the Regulations of Capital Markets Law No. 95 of 1992 (in Arabic)
- Central Securities Depository and Registry Law Law No. 93 of 2000 (in English)
- Central Securities Depository and Registry Law Law No. 93 of 2000 (in Arabic)
- Capital Markets Law No. 95 of 1992
- Executive Regulations of Capital Markets Law No. 95 of 1992

Tax Laws
- Executive Regulations of the Income Tax Law No. 91 of 2005
- General Sales Tax Law No. 11 of 1991
- Income Tax Law No. 91 of 2005 (in Arabic)
- Income Tax Law No. 91 of 2005
- Law No. 17 of 2001 on the Application of the Second and the Third Phases of the General Sales Tax
- Law No. 11 of 2002 on the Explanation of Certain Provisions of General Sales Tax Law No. 11 of 1991

Trade Laws
- Customs Law No. 66 of 1963, as amended by Law No. 95/2005
- Customs Tariff

Islamic Republic of Iran

Banking and Credit Laws
– Law for Usury (Interest) Free Banking
– Monetary and Banking Law
– The Law for Usury (Interest)-Free Banking

Bankruptcy and Collateral Laws
– Civil Code (from Art. 771)

Civil Codes
– Civil Code
– Civil Code

Commercial and Company Laws
– Civil Code
– Commercial Code
– Commercial Code of Iran (1932)
– Law on Encouragement and Protection of Foreign Investment

Constitutions
– Constitution of Iran
– Constitution of Iran (in Farsi)

Labor Laws
– Labor Code
– Labor Law

Securities Laws
– Joint Stock Companies Act
– Law for the Issuance of Participation Papers

Tax Laws
– Direct Taxation Act

Jordan

Banking and Credit Laws
– Banking Law No. 28 of 2000
– Banking Supervision Regulations (in Arabic)
– Central Bank of Jordan Law No. 23 of 1971

Bankruptcy and Collateral Laws
– Companies Law No. 22 of 1997, as amended

Civil Codes
– Act No. 43 of 1976 of the Jordanian Civil Code

Commercial and Company Laws
– Companies Law No. 22 of 1997, as amended
– Companies Regulation and its Amendments (No. 50 for 1997)
– Competition Law

Constitutions
– Constitution of Jordan
– Constitution of Jordan (in Arabic)

Labor Laws
– Labour Code, Law No. 8 of 1996
– Social Security Law No. 19 of 2001 (draft)

Securities Laws
– Securities Law No. 76 of 2002

Tax Laws
– Social Security Law No. 19 of 2001 (draft)

Lebanon

Banking and Credit Laws
– Banking Secrecy Law pf 3/9/1956 (in Arabic)
– Constitution des Banques Islamiques au Liban (Loi No. 505 du 11 février 2004)
– Law No. 110 of 1991 on Reform of the Banking Sector Regulations (in Arabic)
– Law No. 193 of 1993 on Facilitating the Mergers and Acquisitions of Banks (in Arabic)
– Law No. 308 of 2001 on Bank Share Issuing and Trading, Bank Bond Issuing, and Bank Ownership of Real Estate (in Arabic)
– Law No. 505 dated February 11, 2004 on the Establishment of Islamic Banks in Lebanon
– Law No. 575 of 2004 on the Establishment of Islamic Banks in Lebanon (in Arabic)
– Law No. 99 of 1991 Regarding Lebanese and Foreign Banks (in Arabic)

Commercial and Company Laws
– Investment Development Law 360
– Law 360 Encouraging Investments in Lebanon

Constitutions
– Constitution of Lebanon
– Constitution of Lebanon (in Arabic)

Labor Laws
– Code du travail

- Loi n° 207 modifiant le Code du travail
- Loi No. 207 de 2000

Securities Laws

- Law No. 139 of 1999 on the Establishment of a Central Securities Depository (in Arabic)
- Law No. 705 of 2005 on Assets Securitization (in Arabic)
- Law No. 706 of 2005 on Collective Investment Schemes in Securities and Other Financial Instruments (in Arabic)

Tax Laws

- Law No. 91 - 117

Trade Laws

- Customs Law
- Law No. 105 of 1999 on Authorization to Import, Export, and Trade with Gold and any Other Precious Metals (in Arabic)

Morocco

Banking and Credit Laws

- Circulaire n° 2/G/96 du 30 janvier 1996 relative aux certificats de dépôt
- Circulaire n° 3/G/96 du 30 janvier 1996 relative aux bons des sociétés de financement
- Loi n° 34-03 relative aux établissements de crédit et organismes assimilés
- Loi n° 34-03 relative aux établissements de crédit et organismes assimilés (en arabe)
- Modificatif de la circulaire n° 2/G/96 du 30 janvier 1996 relative aux certificats de dépôt
- Modificatif du 27/07/2001 de la circulaire n° 3/G/96 du 30 janvier 1996 relative aux bons des sociétés de financement
- Modificatif du 26/02/2003 de la circulaire n° 3/G/96 du 30 janvier 1996 relative aux bons des sociétés de financement

Civil Procedure Codes

- Arbitrage (Extrait du code de procédure civile)

Commercial and Company Laws

- Charte de l'investissement (Loi-cadre n° 18-95)
- Code de commerce
- Décret n° 2-03-727 du 2 kaada 1424 (26 décembre 2003) relatif à l'organisation des centres régionaux d'investissement
- Instruction générale n° 714 relative aux droits d'enregistrement

- Loi n° 13-97 relative aux groupements d'intérêt économique (GIE)
- Loi n° 17-95 relative aux sociétés anonymes
- Loi n° 5-96 sur la société en nom collectif, la société en commandite simple, la société en commandite par actions, la société à responsabilité limitée et la société en participation

Constitutions
- Constitution du Maroc
- Constitution of Morocco
- Constitution of Morocco (in Arabic)

Labor Laws
- Code du travail
- Décrets du 16 kaada 1425 (29 décembre 2004) fixant l'application des articles du Code du travail

Tunisia

Banking and Credit Laws
- Loi n°2005-96 du 18 octobre 2005 relative au renforcement de la sécurité des relations financières
- Loi n° 85-108 du 6 décembre 1985 portant encouragement d'organismes financiers et bancaires travaillant essentiellement avec les non-résidents
- Loi n° 5 8-90 du 19 septembre 1958 portant création et organisation de la Banque Centrale de Tunisie,
- Loi n° 2001-65 du 10 juillet 2001, relative aux établissements de crédit, qui abroge et remplace la loi n° 67-51 du 7 décembre 1967 réglementant la profession bancaire modifiée notamment par la loi n° 94-25 du 7 février 1994 et la loi n°2006-19 du 2 mai 2006

Bankruptcy and Collateral Laws
- Loi n° 1995-0034 relative au redressement des entreprises en difficultés économiques
- Loi n° 2003-0079 modifiant et complétant la loi n° 95-34, relative au redressement des entreprises en difficultés économiques

Civil Procedure Codes
- Code de procédure civile et commerciale

Commercial and Company Laws
- Code de commerce
- Code des sociétés commerciales
- Code des obligations et des contrats
- Loi n° 2005-0065 modifiant et complétant le code des sociétés commerciales

- Loi n° 2005-0012 portant modification de quelques dispositions du code des sociétés commerciales
- Law No. 93-120 Promulgating the Investment Incentives Code
- Code d'incitation aux investissements
- Loi n° 92-80 portant création de Zones Franches Economique
- Loi n° 91-64 du 29 juillet 1991 relative à la concurrence et aux prix
- Loi relative au registre de commerce

Constitutions
- Constitution de la Tunisie
- Constitution of Tunisia (in Arabic)
- Constitution of Tunisia

Labor Laws
- Code du travail

Land and Building Laws
- Loi n° 94-89 du 26 juillet 1994 relative au leasing

Tax Laws
- Code de l'impôt sur le revenu des personnes physiques et de l'impôt sur les sociétés

Republic of Yemen

Banking and Credit Laws
- Law on Investment (in Arabic)
- Law on the Exchange (in Arabic)
- Law on Anti-Money Laundering (in Arabic)
- Law on Islamic Banks (in Arabic)
- Law on Banks (in Arabic)
- Law on the Central Bank of Yemen (in Arabic)
- Bill against Money Laundering (in Arabic)

Civil Procedure Codes
- Judicial Code of Conduct (Amendment) 2006

Commercial and Company Laws
- Act No. 22 of 1997 on Trading Companies
- Decree Regarding Act No. (37) of 1992 on the Supervision and Control of Companies and Insurance Brokers
- Act No. 33 of 1992 on Trade Registration
- Law No. 23 of 1997 on Arrangement of Agencies, Branches of Companies, and Foreign Trade Houses
- Investment Law No. 22 of 2002

– Republic Decree Act No. 19 of 1999 on Promoting Competition, Monopoly and Prevention of Commercial Deception

Constitutions
– Constitution of Yemen
– Constitution of Yemen (in Arabic)

Labor Laws
– Labour Code
– Loi n° 35/2002 sur l'organisation des syndicats des travailleurs

Tax Laws
– Customs Duty and Tax Exemptions Accorded to Projects, Promoting of Local Production and Increasing Exports

Trade Laws
– Investment Law No. 22 of 2002
– Customs Duty and Tax Exemptions Accorded to Projects, Promoting of Local Production and Increasing Exports

References and Other Resources

Acemoglu, Daron. 2001. "Credit Market Imperfections and Persistent Unemployment." *European Economic Review* 45 (4–6): 665–79.

Ahmed, Leila. 1992. *Women and Gender in Islam: Historical Roots of a Modern Debate*. New Haven, CT: Yale University Press.

Alesina, Alberto, Silvia Ardagna, Giuseppe Nicoletti, and Fabio Schiantarelli. 2003. "Regulation and Investment." NBER Working Paper 9560, Cambridge, MA: National Bureau of Economic Research.

Allen, Elaine, Nan Langowitz, and Maria Minniti. 2006. "Global Entrepreneurship Monitor 2005: Report on Women and Entrepreneurship." The Center for Women's Leadership, Babson College, MA.

Arabsheibani, G., D. de Meza, J. Maloney, and B. Pearson. "And a Vision Appeared unto Them of a Great Profit: Evidence of Self-Deception among the Self-Employed." *Economics Letters* 67, pp. 35–41.

Assad, R. 2006. "Employment and Unemployment Dynamics." Paper prepared for the Egypt Labor Market Panel Survey 2006 Dissemination Conference, Cairo, October.

Austin, James, Howard Stevenson, and Jane Wei-Skillern. 2006. "Social and Commercial Entrepreneurship: Same, Different, or Both?" *Entrepreneurship Theory and Practice* 30 (1): 1–22.

Batra, Geeta, Daniel Kaufmann, and Andrew Stone. 2003. *Investment Climate around the World: Voices of the Firms from the World Business Environment Survey*. Washington, DC: World Bank.

Berkowitz, D., K. Pistor, and J. F. Richard. 2000. "Economic Development, Legality, and the Transplant Effect." Working Paper No. 308, University of Michigan: William Davidson Institute.

Blanchard, Olivier, and Thomas Philippon. 2004. "The Quality of Labor Regulations and Unemployment." Massachusetts Institute of Technology, Department of Economics, Cambridge, MA.

Cagatay, Nilufer. 1998. "Engendering Macroeconomics and Macroeconomic Policies." Working Paper 6, United Nations Development Programme, New York.

CAWTAR (Center for Arab Women Training and Research). 2001. "Arab Women's Development Report 2001. Globalization and Gender: Economic Participation of Arab Women." CAWTAR, Tunis, Tunisia.

CAWTAR and IFC-GEM (Center for Arab Women Training and Research and the International Finance Corporation- Gender Entrepreurship Market). 2007. " Women Entrepreneurs in the Middle East and North Africa: Characteristics, Contributions, and Challenges." CAWTAR, Tunis, Tunisia, and IFC, Washington, DC.

Deininger, Klaus. 2003. *Land Policies for Growth and Poverty Reduction.* World Bank Policy Research Report. Oxford, United Kingdom: Oxford University Press.

Deere, Carmen Diana, and Cheryl R. Doss. 2006. "The Gender Asset Gap: What Do We Know and Why Does It Matter?" *Feminist Economics* 12 (1 & 2):1–50.

Demirguc-Kunt, A., L. Klapper, and G. Panos. 2007. "The Origins of Self Employment." Washington, DC: World Bank (mimeo).

Djankov, Simeon, Rafael La Porta, Florencio Lopez de Silanes, and Andrei Schleifer. 2002. "The Regulation of Entry." *Quarterly Journal of Economics* 117: 1–37.

Ellis, Amanda. 2005. "Engendering Private Sector Development." World Bank, Washington, DC.

Fernandes, Emilia, and Carlos Cabral-Cardoso. 2006. "The Social Stereotypes of the Portuguese Female and Male Manager." *Women in Management Review* 21 (2): 99–112.

Fischer, Eileen M., A. Rebecca Reuber, and Lorraine S. Dyke. 1993. "A Theoretical Overview and Extension of Research on Sex, Gender, and Entrepreneurship." *Journal of Business Venturing* 8 (2): 151–68.

Flanagan, Scott C., and Aie-Rie Lee. 2003. "The New Politics, Culture Wars, and the Authoritarian-Libertarian Value Change in Advanced Industrial Democracies." *Comparative Political Studies* 36 (3): 235–70.

Fraser S., and F. J. Greene. 2006. "The Effects of Experience on Entrepreneurial Optimism and Uncertainty." *Economica* 73 (290): pp.169–192.

Gentry, W., and R. G. Hubbard. 2001. "Entrepreneurship and Household Saving." Working Paper No. 7894. National Bureau of Economic Research, Cambridge, MA.

Hamilton, B. H. 2000. "Does Entrepreneurship Pay? An Empirical Analysis of the Returns of Self-Employment." *The Journal of Political Economy* 108 (3): 604–31.

Heaton, John, and Deborah Lucas. 2000. "Asset Pricing and Portfolio Choice: The Importance of Entrepreneurial Risk." *Journal of Finance* 55, 1163–198.

Hill, Frances M., Claire M. Leitch, and Richard T. Harrison. 2006. "'Desperately Seeking Finance?' The Demand for Finance by Women-owned and -led Business." *Venture Capital: An International Journal of Entrepreneurial Finance* 8 (2): 159–82.

ILO (International Labour Office). 2003. *Key Indicators of the Labour Market,* third ed. Geneva: ILO Publications.

———. 2006. *Global Employment Trends for Youth.* Geneva: ILO Publications.

IMF (International Monetary Fund). 2004. "Saudi Arabia: Financial System Stability Assessment." Monetary and Financial Systems and Middle East and Central Asia Departments. International Monetary Fund, Washington, DC.

IMF and World Bank Group. 2003. "Algeria: Financial System Stability Assessment including Reports on the Observance of Standards and Codes on the Following Topics: Monetary and Financial Policy Transparency and Banking Supervision." Washington, DC.

Jianakoplos, Nancy, and Alexandra Bernasek. 1998. "Are Women More Risk Averse?" *Economic Inquiry* 36: 620–30.

Johnson-Odim, Cheryl, and Margaret Strobel. 1999. "Conceptualizing the History of Women in Africa, Asia, Latin America and the Caribbean, and the Middle East and North Africa." In *Women in the Middle East and North Africa*, ed. Guity Nashat and Judith Tucker. Bloomington, IN: Indiana University Press.

Kauffman, D., A. Kraay, and M. Mastruzzi. 2007. "Governance Matters VI: Governance Indicators for 1996-2006." Policy Research Working Paper No. 4280, World Bank, Washington, DC.

Klasen, Stephan, and Francesca Lamanna. 2003. "The Impact of Gender Inequality in Education and Employment on Economic Growth in the Middle East and North Africa." Background paper for *Gender and Development in the Middle East and North Africa*. Washington, DC: World Bank.

Kamrava, Mehran. 2004. "Structural Impediments to Economic Globalization in the Middle East." *Middle East Policy* 11 (4): 96–112.

Kourilsky, Marilyn, and William B. Walstad. 1998. "Entrepreneurship and Female Youth: Knowledge, Attitudes, Gender Differences, and Educational Practices." *Journal of Business Venturing* 13: 77–88.

Kunt, A., L. Klapper, and G. Panos. 2006. "The Origins of Self-Employment and Entrepreneurial Performance in Transition Economy." Draft paper. World Bank, Washington, DC.

Laframboise, Nicole, and Tea Trumbic. 2003. "The Effects of Fiscal Policies on the Economic Development of Women in the Middle East and North Africa." Working Paper 03/244, International Monetary Fund, Washington, DC.

Lee, Aie-Rie. 2006. "Value Cleavages, Issues, and Partisanship in East Asia." *Journal of East Asian Studies* 7 (2): 251–74.

Leitch, Claire M., and Frances M. Hill. 2006. "Guest Editorial: Women and the Financing of Entrepreneurial Ventures: More Pieces for the Jigsaw." *Venture Capital* 8 (2): 89–92.

Lewis, Patricia. 2006. "The Quest for Invisibility: Female Entrepreneurs and Masculine Norm of Entrepreneurship." *Gender, Work, and Organization* 13 (5): 453–69.

Livani, Talajeh. 2007. "Middle East and North Africa: Gender Overview." World Bank, Washington, DC.

Mah, Jai M. 1997. "Core Labour Standards and Export Performance in Developing Countries." *World Economy* 20: 773–85.

Moghadam, Fatemeh E. 2001. "Iran's New Islamic Home Economics: Exploratory Attempt to Conceptualize Women's Work in the Islamic Republic." In *The Economics of Women and Work in the Middle East and North Africa*, ed. E. Mine Cinar. New York: JAI.

Molyneux, Maxine, and Shahra Razavi. 2003. "Gender Justice, Development, and Rights." Paper 10. United Nations Research Institute for Social Development; Democracy, Governance, and Human Rights Programme, Geneva.

Moskowitz T., and A. Vissing-Jorgensen. 2002. "The Returns to Entrepreneurial Investment: A Private Equity Premium Puzzle?" *The American Economic Review* 92 (4): 745–778.

Mushaben, Joyce Marie. 2006. "Thinking Globally, Integrating Locally: Gender, Entrepreneurship, and Urban Citizenship in Germany." *Citizenship Studies* 10 (2): 203–27.

Nashat, Guity, and Tucker, Judith. 1999. *Women in the Middle East and North Africa: Restoring Women to History*. Bloomington, IN: Indiana University Press.

Nazir, Sameena. 2006. "Challenging Inequality: Obstacles and Opportunities Towards Women's Rights in the Middle East and North Africa." In *Women's Rights in the Middle East and North Africa: Citizenship and Justice*. Washington, DC: Rowman and Littlefield Publishers. http://www.freedomhouse.org/template.cfm?page=163.

Padmanabhan, P., and K. R. Cho. 1999. "Decision-Specific Experience in Foreign Ownership and Establishment Strategies: Evidence from Japanese Firms." *Journal of International Business Studies* 30 (1): 25–43.

Parker, S. C. 2006. "Learning about the Unknown: How Fast Do Entrepreneurs Adjust Their Beliefs?" *Journal of Business Venturing* 21 (1): 1–26.

Phillips, Anne. 2001. "Multiculturalism, Universalism, and the Claims of Democracy." Paper 7. United Nations Research Institute for Social Development; Democracy, Governance, and Human Rights Programme, Geneva.

Puri M., and D. T. Robinson. 2005. "Optimism, Work/Life Choices, and Entrepreneurship." Working paper, Duke University.

Pyle, Jean Larson. 1990. *The State and Women in the Economy: Lessons from Sex Discrimination in the Republic of Ireland*. Albany, NY: State University of New York Press.

Schumpeter, Joseph. 1975. *Capitalism, Socialism and Democracy*. New York: Harper.

Seguino, Stephanie, and Caren Grown. 2006. "Feminist-Kaleckian Macroeconomic Policy for Developing Countries." Levy Economics Institute Working Paper 446, Bard College, Annandale-on-Hudson, NY.

Singh, Val, Susan Vinnicombe, and Kim James. 2006. "Constructing a Professional Identity: How Young Female Managers Use Role Models." *Women in Management Review* 21 (1): 67–81.

Stotsky, Janet. 1997a. "Gender Bias in Tax Systems." *Tax Notes International* (9 June): 1913–23.

———. 1997b. "How Tax Systems Treat Men and Women Differently." *Finance and Development* 34 (1): 30–3.

———. 2006. "Gender and Its Relevance to Macroeconomic Policy: A Survey." *IMF Working Papers* 6 (233): 1–69.

Tilly, Louise A., and Joan W. Scott. 1978. *Women, Work, and Family*. New York: Holt, Rinehart, and Winston.

Tonoyan, V. 2003. "The Bright and Dark Sides of Trust: Corruption and Entrepreneurship." University of Mannheim, Mannheim, Germany.

———. 2003. "The Dark Side of Trust: Corruption and Entrepreneurship." University of Mannheim, Mannheim, Germany.

Transparency International. 2006. "Press Release: Tackling Corruption is Essential to Making Poverty History, 14 September 2006." http://www.transparency .org/news_room/latest_news/press_releases/2006/2006_09_14_world_bank.

Ufuk, Hatun, and Ozlen Ozgen. 2001. "The Profile of Women Entrepreneurs: A Sample from Turkey." *International Journal of Consumer Studies* 25 (4): 299–308.

Ulusay de Groot, Tezer. 2001. "Women Entrepreneurship Development in Selected African Countries." PSD Technical Working Papers Series. United Nations Industrial Development Organization (UNIDO), Vienna.

United Nations. 2000. *The World's Women 2000: Trends and Statistics*. New York: United Nations.

UNDP (United Nations Development Programme). 2006. *Arab Human Development Report 2005: Towards the Rise of Women in the Arab World*. Palo Alto, CA: Stanford Economics and Finance.

Verheul, Ingrid, Andre Van Stel, and Roy Thurik. 2006. "Explaining Female and Male Entrepreneurship at the Country Level." *Entrepreneurship and Regional Development* 18 (2): 151–83.

Woodhams, Carol, and Ben Lupton. 2006. "Does Size Matter? Gender-Based Equal Opportunity in UK Small and Medium Enterprises." *Women in Management Review* 21 (2): 143–69.

World Bank. 2001. *Engendering Development: Through Gender Equality in Rights, Resources, and Voice*. Washington, DC: World Bank.

———. 2003a. *Doing Business in 2004: Understanding Regulation*. Washington, DC: World Bank.

———. 2003b. *World Development Indicators 2003*. Washington, DC: World Bank.

———. 2004a. *Doing Business in 2005: Removing Obstacles to Growth*. Washington, DC: World Bank.

———. 2004b. *Gender and Development in the Middle East and North Africa: Women in the Public Sphere*. Washington, DC: World Bank.

———. 2004c. "World Bank: Middle East and North Africa Region Strategy Paper." Unpublished, World Bank, Washington, DC.

———. 2004d. *World Development Report 2005*. Washington, DC: World Bank.

———. 2005a. *Doing Business in 2006: Creating Jobs*. Washington, DC: World Bank.

———. 2005b. *Doing Business in the Middle East and North Africa 2006*. Washington, DC: World Bank.

———. 2005c. "Syrian Investment Climate Assessment: Unlocking the Potential of the Private Sector." Confidential Internal Paper. Private Sector, Financial Sector and Infrastructure Group, Middle East and North Africa Region, World Bank, Washington, DC.

————. 2006a. "Djibouti: Economic Monitoring Report." Unpublished, Social and Economic Development Group, Middle East and North Africa Region, World Bank, Washington, DC.

————. 2006b. *Doing Business 2007: How to Reform.* Washington, DC: World Bank.

————. 2006c. "Gender Equality as Smart Economics: A World Bank Group Gender Action Plan (Fiscal Years 2007–2010)." World Bank, Washington, DC.

————. 2006d. "Iraq Economic Monitoring Note." Unpublished, Social and Economic Development Group, Middle East and North Africa Region, World Bank, Washington, DC.

————.2006e. "Lebanon Investment Climate Assessment: Unlocking the Potential of the Private Sector." Unpublished. World Bank, Private Sector, Financial Sector, and Infrastructure Group, Middle East and North Africa Region, Washington, DC.

————. 2006f. "Republic of Yemen Investment Climate Assessment: Priorities and Recommendations for Accelerating Private-Led Growth." Unpublished. World Bank, Private Sector, Financial Sector, and Infrastructure Group, Middle East and North Africa Region, Washington, DC.

————. 2006g. Roundtable on the Role of Women in the Development of the Private Sector of the Middle East and North Africa Region. http://web.world bank.org/WBSITE/EXTERNAL/COUNTRIES/MENAEXT/EXTMNA REGTOPGENDER/0,,contentMDK:20784810~pagePK:34004173~piPK:3 4003707~theSitePK:493333,00.html.

————. 2006h. "Yemen: Economic Monitoring Report." Unpublished, Social and Economic Development Group, Middle East and North Africa Region, World Bank, Washington, DC.

————. 2007a. *Doing Business 2008.* Washington, DC: World Bank.

————. 2007b. Doing Business Database. [www.doingbusiness.org].

————. 2007c. *Global Monitoring Report 2007.* Washington, DC: World Bank.

————. 2007d. "MENA Economic Development and Prospects 2007: Job Creation in an Era of High Growth." Middle East and North Africa Region, World Bank, Washington, DC.

————. 2007e. Worldwide Governance Indicators 1996–2006. http://go.world bank.org/ATJXPHZMH0.

World Values Survey. www.worldvaluessurvey.org.

Zuniga, J., and N. Benhassine. 2005. "Where Did All the Women Go? Female Economic Participation in the Middle East and North Africa." Unpublished. World Bank, Private Sector Unit, Washington, DC.

Index

ECO-AUDIT
Environmental Benefits Statement

The World Bank is committed to preserving endangered forests and natural resources. The Office of the Publisher has chosen to print *The Environment for Women's Entrepreneurship in the Middle East and North Africa* on recycled paper including 25% post-consumer recycled fiber in accordance with the recommended standards for paper usage set by the Green Press Initiative, a nonprofit program supporting publishers in using fiber that is not sourced from endangered forests. For more information, visit www.greenpressinitiative.org.

Saved:
- 3 trees
- 2 million BTUs of total energy
- 309 pounds of total greenhouse gases
- 1,014 gallons of waste water
- 168 pounds of solid waste